IMAGES
of Aviation

GRAND CENTRAL
AIR TERMINAL

IMAGES
of Aviation

GRAND CENTRAL
AIR TERMINAL

John Underwood

ARCADIA
PUBLISHING

Published by Arcadia Publishing
Charleston SC, Chicago IL, Portsmouth NH, San Francisco CA

Printed in the United States of America

Library of Congress Catalog Card Number: 2006928749

For all general information contact Arcadia Publishing at:
Telephone 843-853-2070
Fax 843-853-0044
E-mail sales@arcadiapublishing.com
For customer service and orders:
Toll-Free 1-888-313-2665

Visit us on the Internet at www.arcadiapublishing.com

CONTENTS

ACKNOWLEDGMENTS

The undersigned wishes to take this opportunity to thank the many people who gave generously of their time and resources toward the production of this volume.

To my friend and neighbor, the late Ralph Johnston, I am especially grateful. Without his help and encouragement, the research that went into this book would never have been undertaken. I am also indebted to the late Barbara Boyd, Special Collections librarian, Glendale Public Library, for a wealth of background material gleaned from documents and memorabilia in her keeping.

This material was assembled from numerous sources over decades. All of the contributors who were party to the airport's inception, management, and operation are deceased, including airline captain Sterling Boller, brother of Vernon and Dana Boller; Gilbert G. (Bud) Budwig; Major Moseley's personal secretary, Elaine Carse; Orval Guy; Walter Hengst; Roy L. Kent; Edward Lund; A. L. (Pat) Patterson; L. E. (Al) Phelan; Thomas V. Philp; Thelma Radcliff; Bertrand Rhine; Lloyd Royer; Thomas S. Ryan; Gen. Robert L. Scott; Katherine M. Smith; H. J. (Stew) Stewart; Otto Timm; Wallace Timm; Octave (Tave) Wilson; and Eva O. Young, the widow of Thomas C. (Doc) Young, M.D.

Valuable input came from airline captain Douglas E. Anderson, Blanche Babb, Margaret Pomeroy Bacon, George Blauvelt, Hazel Beilby, Stephen H. Crowe, Frank Dewey, Robert W. Diehl, Phillip Dockter, Special Collections librarian George Ellison of the Glendale Public Library, Carl F. Friend, Col. Royal D. Frye, Capt. Harry C. Goakes, William E. Grago, Richard T. Hart, E. L. Hollywood Jr., James W. Horak, Walter Johnston, Capt. W. B. Kinner Jr., Donna Kinner Hunter, Russell Hunter, Marvin A. Krieger, James K. Montijo, John C. Morgan, Capt. Fred Pastorius, Joseph B. Plosser Jr., Dale Scoville, James Stevenson, Stanley A. Strout, Myron Strawn, the family of photographer Raymond C. Talbott, and WED Enterprises.

Photographic sources included the author's collection and those of the aforementioned Johnston, Boller, Philp, Royer, Scott, Timm, Wilson, Anderson, Grago, Montijo, Stevenson, and the Kinner and Talbott families, as well as the Glendale Public Library, Brand Library, Yoder family, Waldo Waterman, Bill Lewis, Security Pacific Bank, Al Menasco, Air Transport Manufacturing, Jim Hunt, Roy Russell, Gene Clay, William F. Yeager, Garland Lincoln, Betty Crosby Moore, Joe White, Bob Morrison, Jonathan Thompson, Bill Krecek, Dick Whittington, B. C. Reed, C. F. McReynolds, Disney Enterprises, William T. Larkins, Erik Miller of Lockheed, Wayne Irwin, Barbara Collins, Thaheld family, Sky Roamers, and Robert C. Owens.

Finally, I want to express my deepest gratitude to Mary Jane, my wife, for her encouragement, collaboration, and devotion, without which this book would never have been written.

—John Underwood
August 24, 2006

INTRODUCTION

This book is about an airport long gone but by no means forgotten. More importantly, it is the story of a unique collection of individuals who created it and made it function. They were the pioneers of a new industry that had its roots in the city of Glendale. In its heyday, the airport was called Grand Central Air Terminal. It was the first official terminal for Los Angeles and home port to a dozen different air carriers. But that was by no means the beginning.

Glendale folk had front row seats for the opening of the age of air travel. They gazed in wonder as the *California Arrow*, piloted by Roy Knabenshue, droned over the town's modest precincts. Knabenshue planned to operate an airship service, and his exploits, even more than those of the Wrights, put thoughts of air commerce in the minds of Southern Californians. That was in 1906, the year the town incorporated as a dusty country village with less than 2,000 people.

Six years later, with the opening of Griffith Park Aerodrome on the Los Angeles side of the river, Glendale welcomed into its midst a burgeoning community of birdmen. The newest profession, poorly paid as it was, had never lacked a following. It was a young man's game, and new adherents often worked for subsistence wages or nothing at all, just to gain experience. Among the new arrivals listed in the 1913 *City Directory* was Jay Gage, builder of the first planes to fly in Panama and Alaska. Four or five others worked for Glenn Martin, who trundled his biplanes out from Los Angeles and stabled them at Griffith Park. Martin, much in demand for movie and exhibition flying, is said to have preferred Glendale air for his test-flying since it was acclaimed as "the purest and most comfortable to ride upon!"

A far-sighted businessman named Leslie Coombs Brand fostered local air-mindedness by establishing a private hillside airport in 1919 and, two years later, hosted the first "fly-in." This was a highlight of the Los Angeles social calendar. Army fliers passing from March Field and naval airmen from the North Island Air Station often dropped in for a bit of refreshment and conviviality. The bar in Brand's clubhouse, well-stocked with the finest wines and spirits, was always open, and anyone with an airplane was welcome.

Other forward-looking citizens, picking up where the ailing millionaire left off, formed the Glendale Airport Association in 1923. Its purpose was to develop a municipal airport and to nurture the infant aircraft industry. The resulting facility, situated on a tract of ranch land adjacent to the Los Angeles River, was not long in attracting industry. The first hangar, labeled rather pretentiously as the Kinner Airplane and Motor Corporation, was a family affair financed on a shoestring. Bert Kinner had yet to build a marketable airplane engine, but his sprightly Airster biplane quickly captured the fancy of a tomboy called "A. E.," short for Amelia Earhart.

On the opposite side of the field was the modest factory of Messrs. Waterhouse and Royer, initially capitalized with a $300 loan. Another hand-to-mouth operation, it lasted long enough to build half a dozen Roamair biplanes and one monoplane—the Cruizair. W&R, financially strapped, sold the monoplane blueprints to a San Diego upstart called Ryan Airlines, who would be commissioned to build a spin-off that became the most famous plane of all time, the *Spirit of St. Louis*.

Although Glendale never became the manufacturing center its proponents envisioned, it nurtured the seeds of the Southland's greatest industry. The aircraft from which the Convair/General Dynamics line descended were Glendale productions; so were the first planes to bear the names of Jack Northrop and Howard Hughes. Technology pioneered locally made possible such aeronautical milestones as the Douglas DC-3 and some of the finest military aircraft of the 1940s.

War clouds on the horizon brought a frantic rush to bolster the nation's defense posture. Major Moseley's contract school, activated in 1939, played a key role in the air corps buildup. Hitler was on the march, and England soon had her back to the wall. American volunteers were quick to respond, training at Glendale with little fanfare. Many of them distinguished themselves as members of the famed Eagle Squadrons.

The attack on Pearl Harbor turned Grand Central into an armed camp. One side of the airport was given over to the overhaul and repair of training aircraft; the other was a P-38 fighter base. The distinctive wail of turbocharged Allison V-12s, thrilling to younger ears and a bane of older ones, was a comfort to all when a Japanese invasion seemed imminent. Late in 1942, with the arrival of the 318th Fighter Wing, the P-38 outfits became operational training squadrons.

Elements hostile to the airport prevailed in the long run. The runway was shortened after the war, precluding its utilization by new-generation jet transports. Major Moseley's Grand Central Aircraft Company, still the city's largest employer, continued for a time, but the decline hastened after the Korean War. Income from supporting industries and services failed to keep pace with tax increases. By 1959, it was thumbs-down for the airport.

Grand Central Airport, once the aviation showplace of the West, became Grand Central Industrial Center in the 1960s. In the 21st century, it continued as a thriving community of service industries, light manufacturing, and film production, including Dreamworks SKG and WED Enterprises. The terminal and its environs now belong to the Disney interests, who propose to restore the terminal and tower as they were during the 1930s, as a training facility and visitors center.

Nothing remains of the old runways, and little remains to stir up memories of the sights and sounds of bygone eras. But the control tower still stands, and in its shadows a spectral presence lingers. One can sometimes hear a muted beat drifting in with the evening mist. It's freeway noise, of course, but in the mind's eye one can easily imagine a phantom Northrop running up with the night mail for New York.

One

GLENDALE'S ELITE SPROUT WINGS

There were only four automobile owners in the city of Glendale when 23-year-old Thomas C. Young arrived from Iowa in 1908. Quick to avail himself of the latest means of personal transportation, young Tom bought a roadster to commute to his classes at the Los Angeles College of Osteopathy. Seven years later, in partnership with his brother-in-law, A. L. Baird, Tom opened the Glendale Research Hospital. He had by then become a prominent surgeon.

Tom, referred to hereafter as "Doc," which is what everyone called him, must have been bitten by the flying bug that had moved the San Fernando Valley's leading entrepreneur, Leslie C. Brand, to order an airplane soon after the end of World War I. Brand, often referred to as the "Father of Glendale," built his own private landing field at the gates of El Mirador, his palatial estate, which was only a few blocks from the Young residence at 400 West Kenwood Drive.

Brand's famous 1921 April Fool's Day "fly-in" may in fact have inspired Doc to take up flying. Brand invited anyone interested in aviation to attend, the only requirement being that he or she had to arrive by air to be admitted to the open bar and a buffet of culinary delights served on the veranda behind his home. Dozens of planes, including several army DH4s from March Field, were parked outside the gate for all to inspect.

It is unclear when "Doc" was fledged, but the date coincided more or less with the Brand event, which drew nearly 100 of Southern California's leading fliers. Doc's name doesn't appear on the guest list, but he almost certainly was there, looking over the latest model aircraft parked outside the gates, which included Cecil B. De Mille's six-passenger Junkers monoplane, imported from Germany.

Shortly thereafter, Doc paid about $1,000 for a surplus Curtiss JN4D, which had cost the government $6,600 in 1917. Glendale aviator Reeve Darling, considered an old-timer in the game, flew the "Jenny" up from San Diego's North Island with Doc in the passenger seat. Doc took some lessons from Darling, a florist by trade, and was soon flying the Jenny by himself. He became something of a gadabout, hopping all over Southern California to attend air meets and the occasional airport opening.

Doc became an ardent believer in the future of aviation at a time when the government was making drastic postwar cuts in its aviation programs. Moreover, he believed that Southern California was going to be a major center of activity. At that time, Loughead Brothers (pronounced Lockheed) in Santa Barbara was regarded as the leading manufacturer in terms of dollar volume,

with a little-known youngster named Douglas a close runner-up. But their total output could be counted on the fingers of one hand.

Venice, California, was then the center of manufacturing activity, with "factories" operated by Waldo Waterman, Harry Crawford, and one or two others building custom aircraft to order. Also, W. B. ("Bert") Kinner had switched from converting Ford Model Ts into affordable sportscars, to building "sport-planes." Kinner had a shop near the University of Southern California campus and a flying field on Long Beach Boulevard at Tweedy Road in Lynwood, where he carried joyriders and sightseers on weekends.

Doc and a few fellow enthusiasts formed the Glendale-based Western Aero League to help nurture the new industry. At that time, hardly any airports were worthy of the label. Indeed, most cross-country flights involved landing in someone's pasture or whatever open space was available, often with unhappy results. Doc, having learned the hard way that proper landing facilities were essential to commercial aviation's development, very quickly become a vocal advocate for municipal airports and the WAL's chief spokesman in that department.

At that time, Brand's private airport, situated on a seven percent slope, was the only airfield in the Glendale-Burbank area. Griffith Park, soon to be reconstituted as a National Guard air base, had been abandoned as an airfield in 1917. The problem with Brand's airport was the mountain on one end and tall eucalyptus trees on the other, which made for a potentially dangerous combination. One needed to be a better-than-average pilot to sideslip in for a landing.

A movement to establish a proper municipal airport at the bottom end of Grandview, parallel to San Fernando Road and the Union Pacific tracks, led to the appropriation of funds to buy 35 acres of open ranchland surrounded by orchards. The sale was rescinded when certain influential citizens complained that the sub rosa deal was illegal, which meant that a municipal bond issue had to be voted on. It failed in the referendum. Doc saved the day by organizing an investment group to make the airport a reality, mostly with his own money. He was fond of extolling the virtues of Glendale air, which he claimed was not only the purest to breathe, but the most comfortable to ride upon. Doc's was the first hangar built on the Glendale Airport, which was officially dedicated with an air show on March 17, 1923.

Bert Kinner erected the second hangar. A self-taught mechanic who was something of a wizard at improvising and innovating, Kinner manufactured a little two-passenger biplane called the Airster. In an effort to produce an affordable air flivver, Bert was tinkering with his own 60-horsepower engine, a three-cylinder affair copied from the Lawrence L-series, which had been developed for the army, primarily for its Messenger plane and the pony blimp programs. Kinner got a few L-2s and L-3s from government surplus and imported several Anzani radials from France, but they were far too expensive for the mass market he envisioned.

Kinner had sold his Airster demonstrator to a tomboy called A. E., who made a flight to 14,000 feet during an air show, which made her something of a national celebrity. Nobody went much higher than 2,000 or 3,000 feet in those days. Five thousand feet was about the limit. Indeed, the ubiquitous "Jennys" had become so asthmatic from a combination of wartime use and postwar abuse as to be incapable of greater heights.

A. E. ordered a simplified model Airster with Kinner's first Glendale-built engine. It was known as the "Crackerbox," because the fuselage was a streamlined plywood box with no frills. Doc liked the way the Airster flew and placed an order for an improved version, which had a six-cylinder Anzani of 80 horsepower and room for three persons, if they weren't too hefty. It differed from A. E.'s mainly in having some fairings to soften a disconcerting resemblance not so much to a cracker box, but to a coffin with wings.

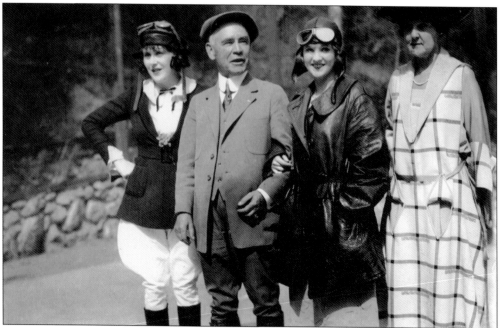

Banker L. C. Brand, Glendale's foremost entrepreneur, detested arduous treks by car to his beloved hunting retreat in the High Sierras and resolved to fly there in his own plane as soon as practicable after World War I. He is pictured here with actresses Ruth Roland, left, Mary Miles Minter, and Mrs. Brand, right, hosting the first "fly-in" since the invention of the airplane.

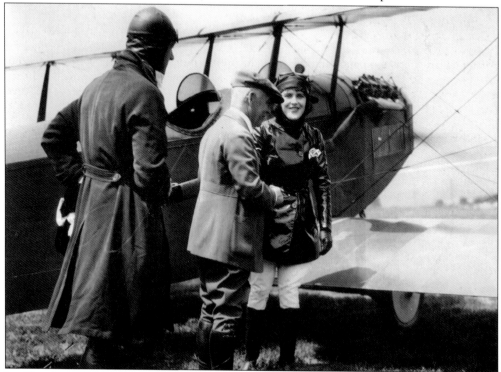

Les Brand greets actress Ruth Roland while her chauffer, aviator E. C. Robinson, looks on.

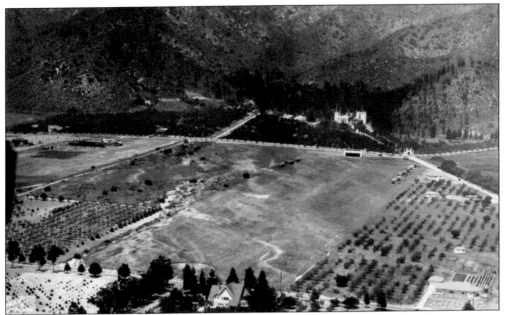

The Brand Aerodrome, on 15 acres purchased from rancher Henry Edwards, whose home appears in the foreground, was situated on a seven percent slope, with Mount Verdugo posing a formidable backdrop. Landings were uphill and takeoffs downhill, regardless of wind direction. There was far more suitable terrain at the bottom of Grandview Avenue, but Brand was determined to commute by air almost from his very doorstep.

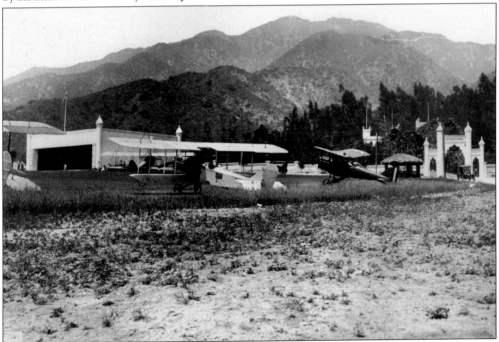

Brand enjoyed sharing his enthusiasm for flying with everyone and hosted the first "fly-in" in the history of aviation on April 1, 1921. A pair of Standard J-1s and an SE5A appear in the foreground, with Brand's customized "Jenny" beside the hangar.

Cecil B. DeMille's elegant Junkers F-13 represented the ultimate in personal air transportation at Brand's fly-in. Built entirely of metal, it foretold the shape of airliners of the future.

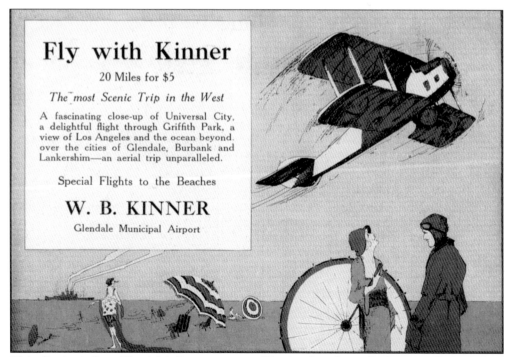

Fly with Kinner

20 Miles for $5

The most Scenic Trip in the West

A fascinating close-up of Universal City, a delightful flight through Griffith Park, a view of Los Angeles and the ocean beyond. over the cities of Glendale, Burbank and Lankershim—an aerial trip unparalleled.

Special Flights to the Beaches

W. B. KINNER

Glendale Municipal Airport

This clipping is from Glendale's flying magazine, *The Ace*. Joyrides and sightseeing flights helped feed the Kinner family when airplane sales were few, sometimes months and years apart.

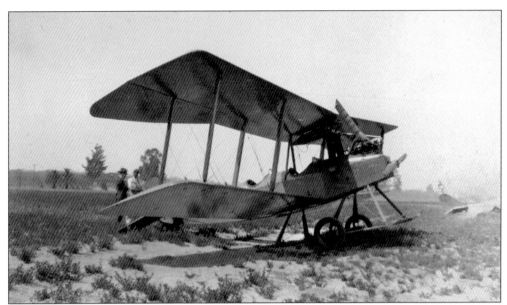

An itinerant flier brought this Boeing "C" to Glendale for an overhaul. It formerly served the U.S. Navy as a trainer on pontoons. Bert Kinner, in white shirt, is seen making an estimate of the cost. Repairing war surplus aircraft helped keep the business afloat.

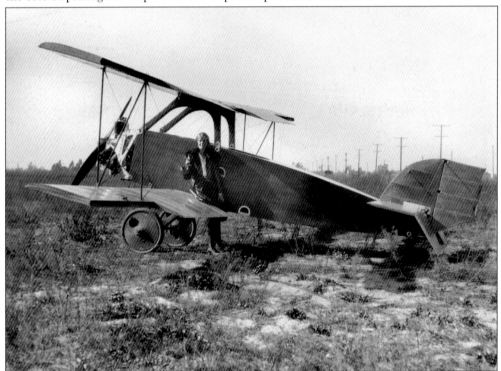

Amelia Earhart takes delivery of her second Kinner Airster, commonly referred to as the "Crackerbox." The engine was a close copy of the Wright L-2 Gale but ran rough and tended to put A. E.'s feet to sleep. Both the airplane and the engine were experimental, and she relished the role of test pilot.

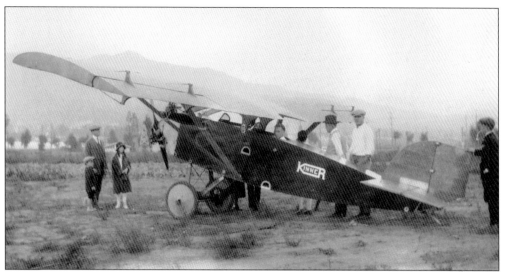

Bob Starkey was the test pilot for the first Kinner Airster monoplane. It was intended to be offered with either the open cockpit or with a fully enclosed cabin for two side-by-side. Pilots still preferred biplanes, and no sales were forthcoming.

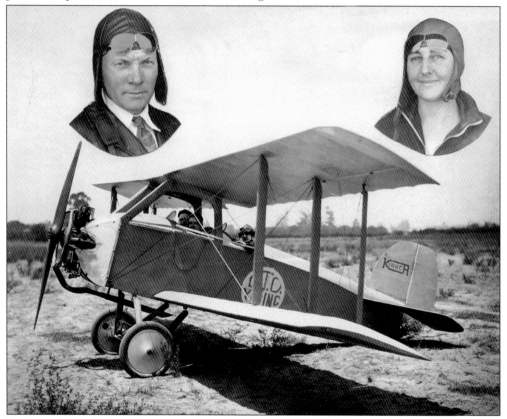

Dr. Young's first Kinner Airster, similar to A. E.'s, was a bit snug as a three-seater but performed well with the 60- to 80-horsepower Anzani imported from France. Eva, Doc's wife, became his enthusiastic copilot.

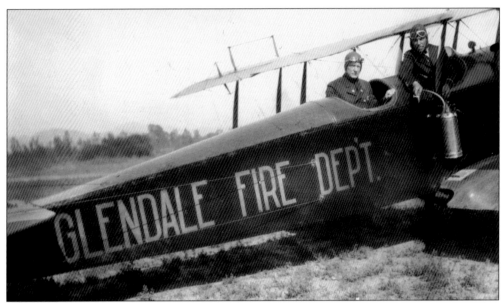

The Glendale Fire Department's Chief Lankford and engineer Tom Philp demonstrate the latest in the city's arsenal of firefighting equipment. The state and federal forestry services used planes to spot fires, but the Glendale Fire Department's "Jenny" was the first aircraft used in municipal service.

Kinner's production line is seen here in early 1923. The skywriting SE5A *Skyscriber* is being overhauled behind the Montijo and Royer *California Coupe*.

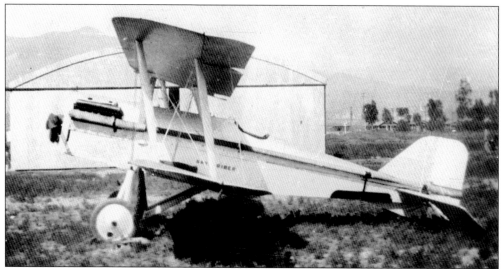

Skyscriber, one of eight ex-Royal Air Force SE5A fighters imported from England as smoke writers by the Skywriting Company of America, is ready to perform in the interests of Lucky Strike cigarettes.

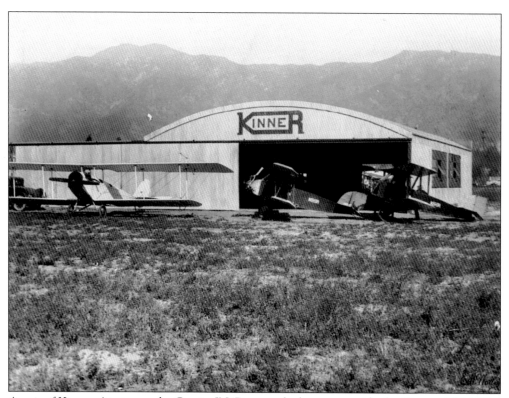

A pair of Kinner Airsters and a Curtiss JN4D are parked at rest outside the Kinner A&M. The business was a hand-to-mouth operation, kept afloat by a few flying enthusiasts like Doc Young and Amelia Earhart, while Bert Kinner, the inveterate tinkerer, perfected his engine.

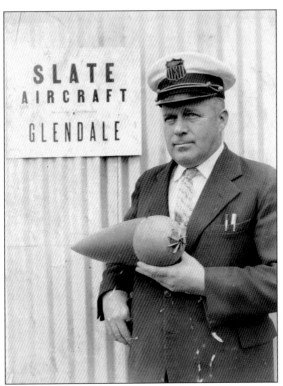

Capt. Tom Slate, the inventor of dry ice, arrived at Glendale in 1925 with a model of his all-metal airship and elaborate plans to establish a manufacturing center at the airport. The protoype *City of Glendale* featured steam-turbine propulsion, which proved impractical in the full-scale application and was replaced by conventional engines.

The Slate crew is pictured with a larger model of the *City of Glendale* in front of city hall. The Glendale Hotel, visible in the background, was to be a terminal for a coastwise service. Passengers were to have been off-loaded by elevators on a cable, which would probably not have worked well in even a slight wind.

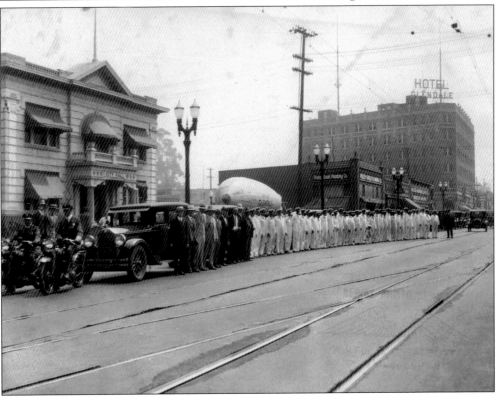

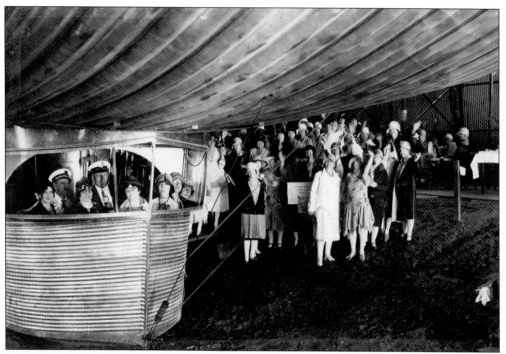

Captain Slate, with a rather dour looking helmsman, gives the lady's bridge club of the Glendale Symphony Orchestra Association a tour of the *City of Glendale*.

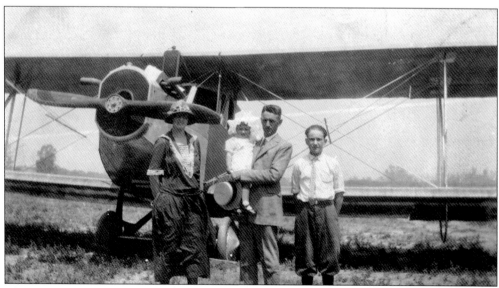

The Kinner family poses with Doc Young's *Argonaut* in May 1924. Pictured, from left to right, are Cora, Bert, baby Donna, and eldest son Winfield B. Jr.

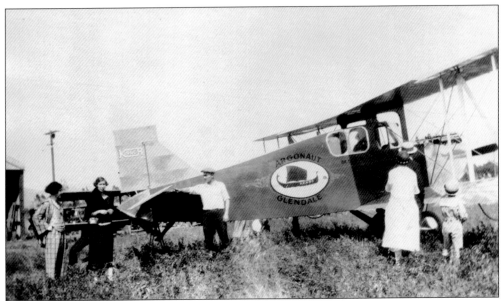

Doc Young's *Argonaut* had a role in launching many young couples into matrimony. Aerial weddings became popular in Southern California and elsewhere in the mid-1920s.

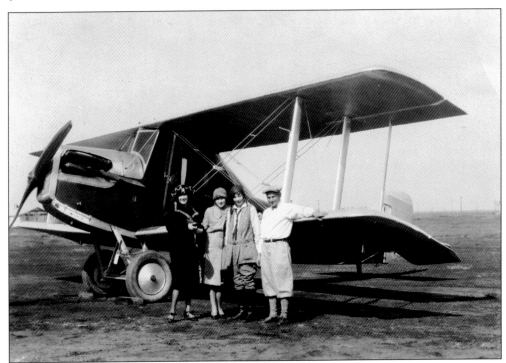

This is the rollout of the California Coupe, chartered for an aerial wedding, with pilot John G. Montijo doubling as best man. "Monty" was under contract to Sam Goldwyn when a stuntman missed a cue, resulting in a head-on collision with a car. Monty was unharmed, but the coupe was totaled.

Two

THE MOM-AND-POP
AIRPORT

The Kinner operation was largely a family affair. Cora Kinner ran the office and had charge of the sewing department. The Airster had fabric-covered wings, which necessitated lots of stitching. Everyone helped out, even the littlest Kinners. They lived next to the airport at 1201 Flower Street in an old frame house. After he moved in, "Bert" was summoned by the Glendale police chief.

"Kinner," said the chief, "we need a man out there to keep an eye on things. Some of these young aviator fellows are real hell-raisers! There'll be no trick flying over this town. Arrest anyone you catch breaking the rules!" The deputy badge brought in an extra $25 a month.

Glendale had a forward-looking fire chief in the person of Art Lankford. The chief had taken a keen interest in aviation and was convinced he could do a better job of quelling brush fires in the foothills if he had an airplane. It was too visionary an idea to gain municipal support, so Lankford acquired a Curtiss JN4D from war surplus, using $600 of his own money to buy it.

Engineer Tom Philp, who had been a flying enthusiast since attending the 1910 International Air Meet at Dominguez Field, became the chief's assistant. The Jenny was refurbished in Kinner's shop, and Langford took about a dozen flying lessons from Jack Rand before he deemed himself sufficiently proficient to take the bright red Jenny aloft on his own. He was soon sharing his newly acquired skills with Philp.

The GFD Jenny was much in the news. An item published in *Popular Mechanics* drew queries from firemen everywhere who, like Lankford and Philp, could see a future for the airplane in the firefighting business. But the JN4D fell short of expectations as an aerial fire wagon. Its usefulness was limited by a disinclination to rise with much more than Lankford and his bullhorn and a fire extinguisher aboard. With Philp aboard the fire extinguisher had to remain behind.

Late in 1923, Kinner rented space in the back of his hangar to Messrs. Montijo and Royer, who were collaborating on the construction of an aerial limousine. John G. Montijo, a wartime flight instructor, was one of the most experienced airmen in the West. His star pupil was Amelia Earhart, whom he'd soloed. Lloyd Royer was a top-notch mechanic and welder. Both had been involved with flying for a decade or more and had some ideas about the kind of airplane that would make aviation a paying proposition.

The Montijo and Royer airplane was a five-passenger biplane with a completely enclosed cabin. There were no other cabin planes in the West at that time, and as soon as Doc Young saw the blueprints he decided that he would have to have something along similar lines. Kinner was commissioned to design and construct an aircraft around a 200-horsepower Renault engine. Doc wanted to fly the new cabin job by summer, preferably before Montijo and Royer. He liked

being a trendsetter. Everyone in the shop was eager to see that he was not disappointed, for Doc was their meal ticket.

By the middle of May, Doc's biplane was ready to fly and in need of a name. A name-the-plane contest was held, with a $50 cash prize to the winner. A carpet salesman wrote "Argonaut" on a penny postcard and was judged the winner. Doc liked the allusion to Jason's vessel from Greek mythology.

The Argonaut was trundled out for its christening on Sunday afternoon, May 25, 1924. A total of 1,500 well-wishers showed up, and several newsreel camera crews were there to film the event. Doc went up in his Airster to sample the atmosphere. "It's perfect," he reported, "Not a bump!" Kinner took charge of the controls for the first hop and was off the ground and circling at 1,000 feet in three minutes. Doc was delighted. It was all he had hoped for and much more.

There was talk of making Glendale the air terminal for Los Angeles. Air Mail service to the Southland was in the offing, and the airport was ideally situated geographically, but the 1,200-foot runway was too short for commercial operations. Moreover, the city had strung a power line near its southern extremity. The wires had already been the cause of several accidents. Doc Young pleaded with the city council to put the wires underground, but the appeal fell on deaf ears.

Three weeks later, the *Shenandoah*, northbound from San Diego, droned overhead. It was lunch hour, and thousands gathered on the rooftops of Glendale's business district to watch the huge airship on its course to San Francisco. There was an escort of three Vought VE-7s from North Island Naval Air Station. Having completed their mission, the navy pilots landed at Glendale and remained until late afternoon.

A protracted takeoff, possibly the result of a downwind departure, put the flight leader, Lt. Cdr. G. C. Dickman, on a collision course with the wires. Dickman may not have known they were there until he was off the ground. In any event, he pulled up sharply and stalled. The two-seater veered to one side, careened off the roof of Doc Young's hangar, and crashed in flames. The observer escaped with minor injuries, but Dickman lost his life.

The Dickman tragedy resulted in an immediate inquiry. The wires, clearly a menace to air traffic, were reason enough to place Glendale off-limits to government aircraft. Such an edict would certainly have put an end to any hopes of making the airport a terminal for the U.S. Mail. The presence of the wires had already had a deleterious effect on the airport. Whereas 19 planes had been based there before the power lines were strung, only three remained at the time of the Dickman episode.

Unaccountably, the wires were allowed to stand. Even so, the Glendale Airport managed to survive and, indeed, prosper. With the advent of the Wilson Brothers in 1926, it became a frequent location for motion picture filming, which was a Wilson specialty. Just a few blocks away, on Lake Street, the Thunderbird Aircraft Corporation began production of their H-10 biplane, and the Henderson brothers, Cliff and Phil, opened a Thunderbird sales office on the airport.

Capt. Tom Slate had the most ambitious plans of all. The inventor, with a wide range of products to his credit, promised to make Glendale the airship capital of the West, if not the world. He constructed a huge hangar and began building an all-metal airship to be christened the "City of Glendale." It was designed to carry 40 passengers and was to employ a form of jet propulsion. Few doubted that within a few years there would be a Glendale airship in every port.

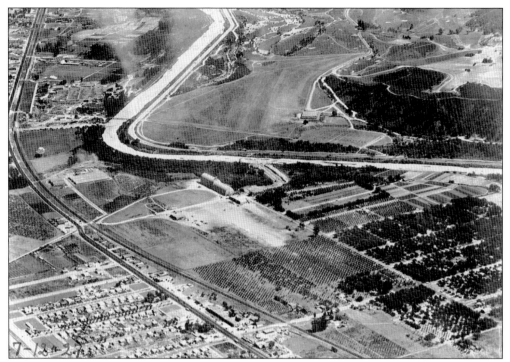

The Glendale Airport is seen here on July 12, 1927. A dirt extension of Grandview Avenue marks the southern extremity, and a peach orchard approximates what is today the end of Paula Avenue at Flower Street, the northern boundary. Over the Los Angeles River is the Griffith Park Airport.

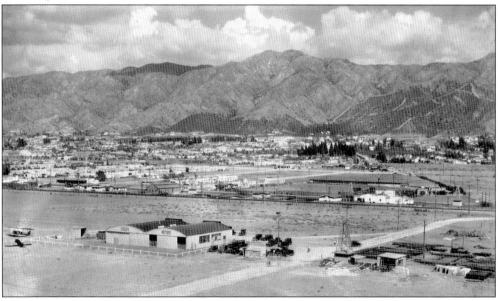

This view looks north towards Brand Park at the far end of Grandview Avenue. The number of cars suggests that Bert Kinner's workforce, numbering at least 20, was busy with one of its first orders for a production batch of engines. It is a weekday and the fold-up beer and sandwich joint seems to be closed.

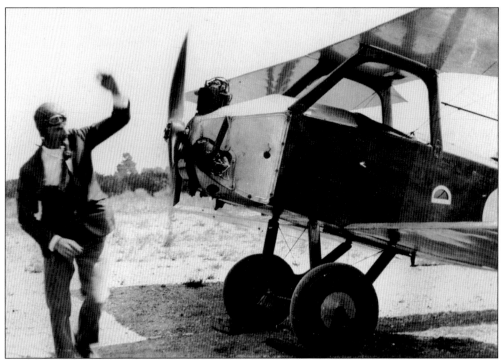

Waldo Waterman, pipe securely clenched, swings his own prop in the absence of an assistant. He got a job working for Glenn Curtiss at San Diego in 1910 and remained prominent in California aviation circles well into the 1970s. Waldo had planned to enter the Airster in the 1925 National Air Races but was a nonstarter.

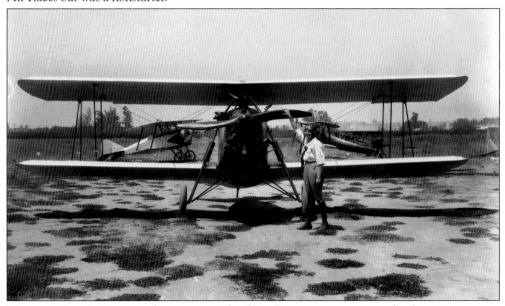

Margret "Marty" Bowman, the teenage wife of Les Bowman, was among the first airwomen to aspire to a career as a commercial pilot. She is pictured here with her personal Kinner Airster, equipped with an early five-cylinder Kinner K5. Marty became a leading racing pilot and field sales representative for Waco and Stinson.

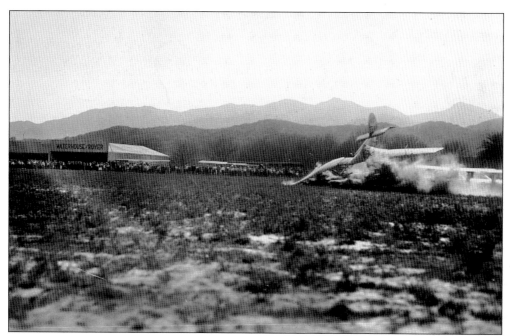

Al Gilhausen, with Ken Barbee as his passenger, was determined to win the spot-landing contest at the annual Glendale Air Rodeo on March 15, 1925. He hit the mark precisely, but the impact destroyed his Curtiss JN4D "Jenny." Both occupants were unharmed. Gilhausen went on to a career with United Airlines.

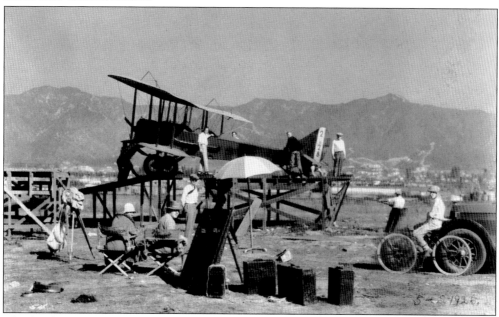

The disadvantages of the short runway did not discourage the Wilson brothers, Roy and Octave (Tave), from establishing a charter business at Glendale. Former Midwestern barnstormers, the brothers were used to short fields. Glendale was ideally suited to their principal activity, movie stunt flying. Their specialty was crash scenes. An old Standard J-1 is about to be sacrificed to achieve technical authenticity.

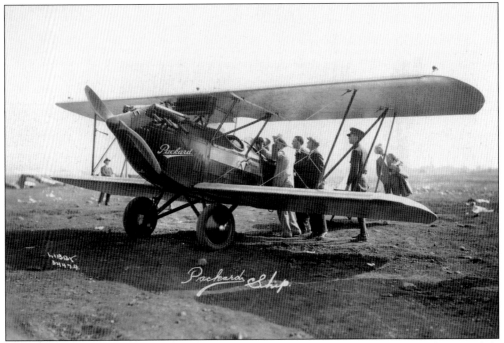

This was the last of six Waterhouse and Royer Romairs. Built for Pasadena Packard automobile dealer Doneld Mc Daneld, it had a 180-horsepower Hispano engine, contrary to the make implied by the inscription. The Romair remained active until World War II.

Lloyd Royer got into aviation in 1914 and served as a skilled airplane mechanic in World War I. In the early 1920s, he drove a gravel truck part-time for Amelia Earhart, and then partnered with John G. Montijo to build the California Coupe in 1923. The firm of Waterhouse and Royer, formed with a $350 loan from the Kinners, built seven aircraft and lost money. Thereafter, Royer enjoyed steady jobs with Lockheed, North American, and Bendix.

Pictured with the one-and-only Waterhouse and Royer Cruisair are, from left to right, salesman A. L. "Pat" Patterson; Lt. Cdr. Esten Kroger, USN; designer W. J. "Bill" Waterhouse; and Oregon customer H. S. Tharp, Klamath Air Service. W&S were in financial trouble when they sold the blueprints to San Diego upstart T. Claude Ryan, who used them to produce mail planes for Pacific Air Transport and a spin-off named the *Spirit of St. Louis* for an unknown mail pilot called "Slim": Lindbergh.

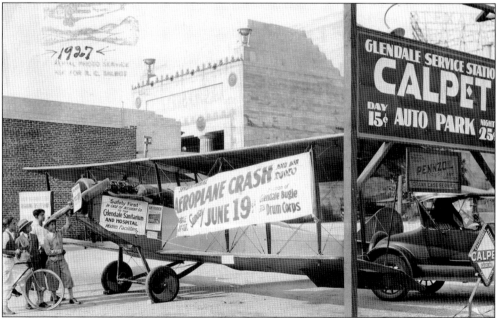

Young Glendalians inspect a sacrificial "Jenny" parked behind the Alex Theatre to advertise the annual Air Rodeo slated for Sunday, June 19, 1927, honoring Charles Lindbergh. Stunt pilot Fin Henderson was slated to crash the JN4C into a bungalow parked on the runway, but the feds intervened on the grounds of safety. The crowd of 10,000 got their money's worth, though, when Owen Dresia accidentally crashed his World War I-vintage Thomas-Morse Scout into a Sonora Avenue peach orchard.

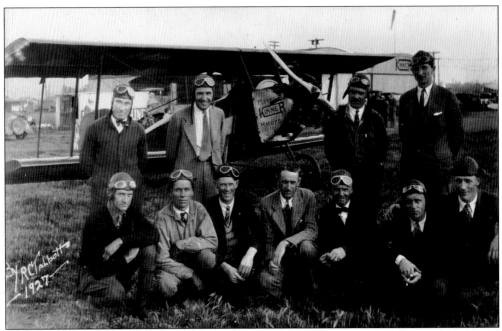

Bert Kinner is flanked by members of the West Hollywood Flying Club, which purchased the Airster used to service-test the 90-horsepower K5 engine. By this time, Kinner had orders for 11 engines but insufficient working capital. Doc Young became an officer-shareholder and financed a modest production line.

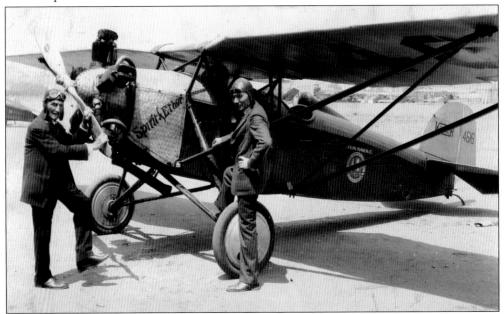

Bert Kinner had perfected the five-cylinder K5 (rated at 90 horsepower) due in part to support and encouragement from Doc Young, who bought S/N 9 off the production line and had Kinner build a two-seater called the *Spirit of Ether*. It featured folding wings and could be trundled home and stored in a single-car garage. Doc gets some cranking pointers from a 95-year-old flying enthusiast.

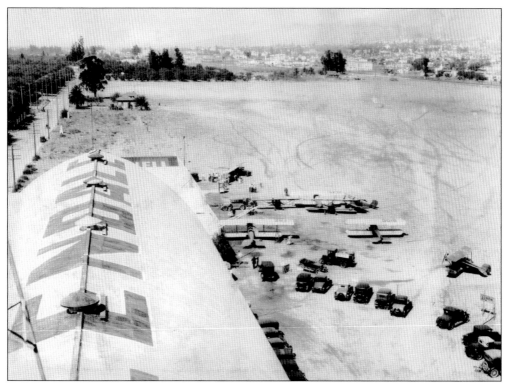

A view of the airport from Slate's hangar is seen down Flower Street towards Sonora Avenue in late 1928. Facing the palm tree is the Kinner family residence, a way station for itinerant fliers. George Law's Monocoupe demonstrator is the only monoplane visible.

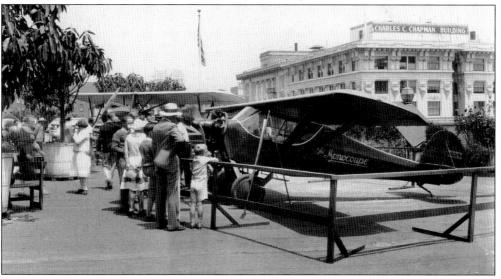

George Law's Monocoupe, NC6730, was detailed to the May Company roof gardens with Bobbi Trout's International to advertise the coming 1928 National Air Races. Monocoupes distinguished themselves in racing events, becoming the first closed-cabin sport planes to enjoy popularity. NC6730 remains aloft in the California Museum of Science and Industry at Exhibition Park, Los Angeles.

Amelia Earhart was already a famous houseguest at 1201 Flower Street, the Kinner residence and corporate headquarters for Kinner A&M, as well as the airport manager. Pictured, from left to right, are A. E., Donna Kinner, and Bert Kinner. Earhart was on her first aerial outing since her 1928 transatlantic hop in the *Friendship*.

A. E. purchased an Avro Avian, G-EBUG, from Lady Mary Heath while in England and made a newsworthy coast-to-coast round trip in the fall/ winter of 1928. The gentleman on the left is Lt. Brian Shaw, a former Royal Air Force pilot, to whom "BUG" was entrusted for a joyride with a girlfriend.

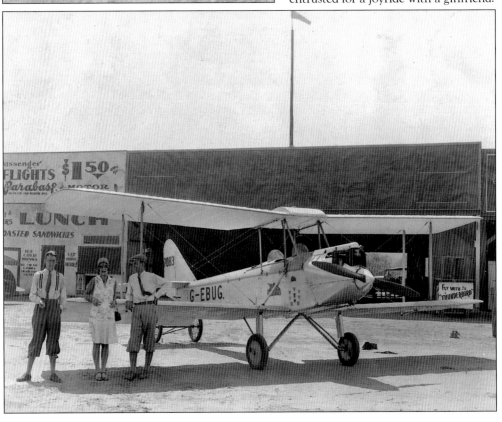

Shaw was a fine pilot trained in the RAF, but it just wasn't his day and he landed BUG with a crunch, prompting A. E. to quip, "That's what you get when a gentleman tries to handle a high-strung lady's plane!" The lady in the helmet was Shaw's joyrider.

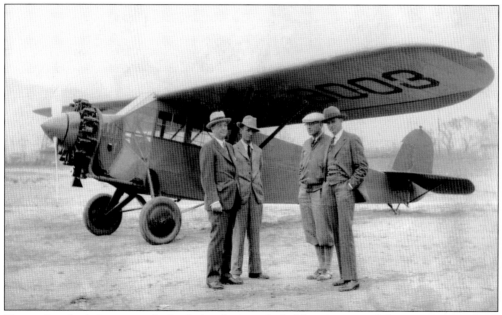

George Law had the agency for both the chummy little Monocoupe and the more commodious Fairchild FC2. He is pictured in cap and knickers with Charles A. La Jotte, who taught Howard Hughes to fly. The gentlemen on the outside had chartered the FC2 for a business trip. Law migrated south of the border with NC8003 as the Depression deepened, to airlift supplies to isolated mountain mining communities.

The *Argonaut*, rebuilt after a crash as an open cockpit five-seater, was sold to the promoters of a Guatemalan airline. It was ferried to El Paso, Texas, by a rascal called Sid Neighbors, who paused at the border to carry joyriders by day and Mexican hooch by night. An accident grounded the *Argonaut*, and Neighbors vanished, leaving his hotel bill unpaid.

The Wilson Aero Service troupe, pictured here from left to right, are Harry Crandall (killed in flying accident, 1932), two unidentified mechanics, Roy Wilson (killed in flying accident, 1932), photographer R. C. Talbott, Jerry Phillips, Bob Starkey (killed in flying accident, 1934), Louie Roepke, "Tave" Wilson, and "Snooky" Richardson, the littlest trouper.

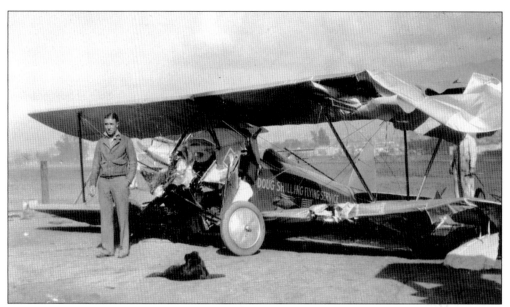

Doug Shilling is pictured with the remains of his Kinner Airster after a head-on midair collision. Two Airsters took off from opposite ends of the runway in dead air, without due regard for what might be happening at the other end. They impacted 10 feet in the air. Henry Batson, the other pilot, was hospitalized for a week.

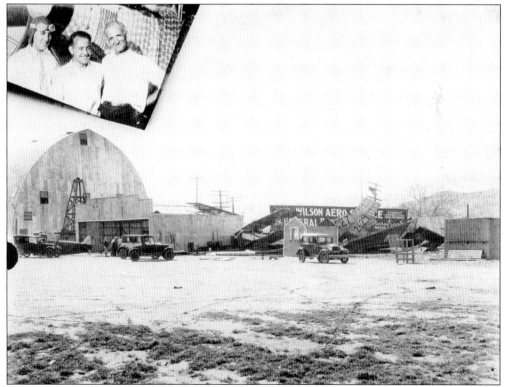

The Wilsons probe for salvageable airplanes after a cyclone destroyed their hangar. The Timm brothers rebuilt the Ryan and two Standards.

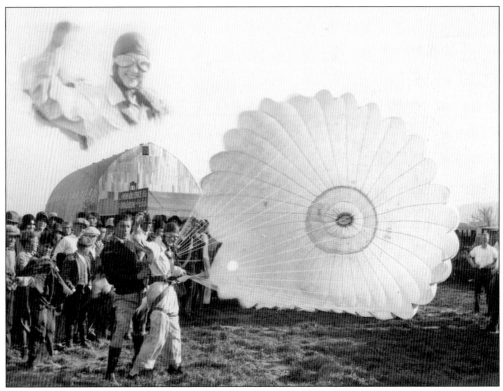

Miss Glendale, Ida Lavina Smith, tried skydiving as an added public attraction to the rollout of Captain Slate's *City of Glendale* dirigible. For her services, she received a stock certificate, which proved to be absolutely worthless the next day.

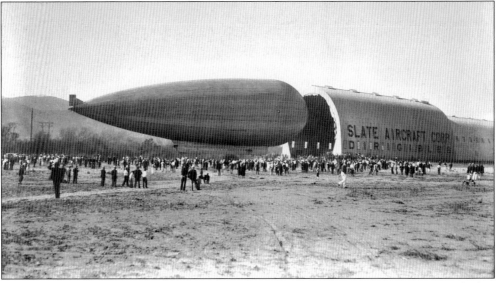

The *City of Glendale* is pictured out of its cavern and aloft, more or less. It never got much higher off the ground. A relief valve jammed, and expanding gas, heated by the sun, burst its seams. The popping rivets sounded like gunfire, and horrified spectators scurried in all directions, fearful of an explosion. Repairs proved impractical, and the dirigible was eventually dismantled for scrap.

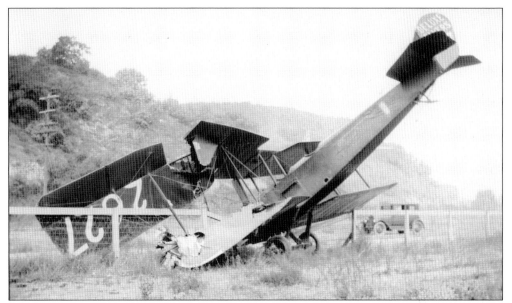

The Wilson Brothers Standard SJ-1 stands here on its nose. It may have been a deliberate stunt for a movie and maybe not. Roy Wilson, piloting his mother to California from the family home in Missouri, is reputed to have been the first Standard pilot to cross the Continental Divide.

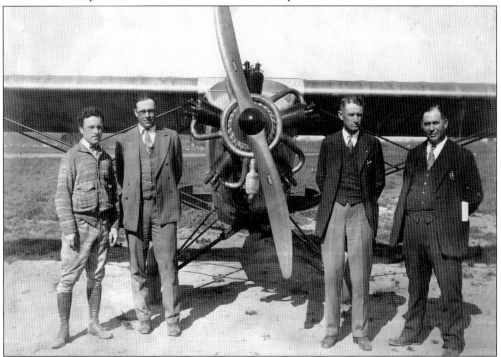

One of Bert Kinner's early customers was J. O. "Joy" York, who had a storefront "factory" on Los Feliz Boulevard near Brand Boulevard. York's three-place Actavian seemed to hold great promise, but an accident alarmed investors and put the underfunded company on the fast track to oblivion. Pictured, from left to right, are York, test pilot Howard Maish, Bert Kinner, and secretary-treasurer Tom Grant.

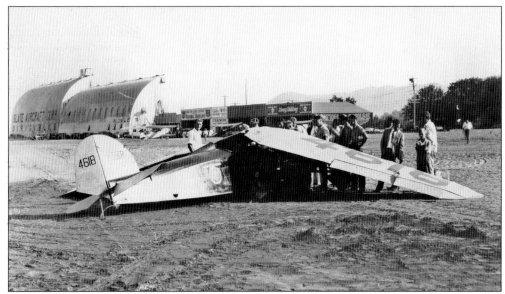

Doc Young's *Spirit of Ether* lies in a heap after it suffered an altercation with a tractor grading a new runway for what was to become Grand Central Air Terminal. The good doctor had mistaken the tractor's dust cloud for a "dust devil." No one was seriously injured, but the *Spirit of Ether* was indisposed for months afterward.

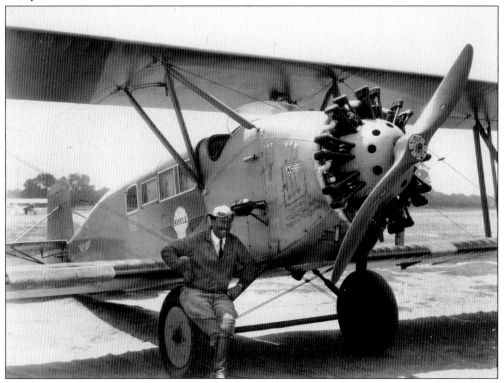

Roscoe Turner's Timm *Golden Shell Special*, conceived for transporting sportsmen to High Sierra hunting lodges, was used in several unsuccessful bids to establish an endurance record. The airplane performed poorly, and Roscoe abandoned the effort to work for Howard Hughes.

Three

NEW HORIZONS
HIGH FINANCE TAKES CHARGE

It took an investment capitalist to achieve what Doc Young and the air-minded citizens of Glendale had sought in vain. Repeated efforts to finance a municipal airport through bond issues had been rebuffed. Finally, late in 1928, Capt. Charles C. Spicer stepped forward. A concerted effort had been mounted to establish a proper municipal airport for Los Angeles, and seven sites were under consideration.

The favored sites were Dominguez Field, where the first American air meet had been held in 1910; Griffith Park, which had been functioning off and on as an airfield since 1911, most recently as a National Guard airbase; and a tract of farmland in Inglewood called Mines Field. None of them had the advantages offered by Glendale. Mines Field, which would come into its own in the decades ahead as LAX, was considered too remote from the Los Angeles Civic Center.

Spicer, sensing it was now or never, formed a new syndicate of venture capitalists. They bought the then 45-acre airport and began expanding to the north and west, eventually consolidating 175 acres. It was to be an airline terminal from the outset, and the architects laid their plans accordingly. The main runway, aligned with the prevailing northwest-southeast winds, was 3,800 feet of concrete 100 feet wide. Till then, there had been nothing like it in the West.

Well-heeled flying enthusiasts, headed by Doc Young and including members of the entertainment world, envisioned a swank aviation country club. Provisions were made for a 2,500-foot turf taxiway/cross runway at the airport's southwestern extremity. This establishment, to be built under the auspices of the Flying Club of California, would comprise a complex of guest rooms and recreational facilities, with an Olympic-class swimming pool and tennis courts. Affiliated aviation country clubs had already appeared at Long Island, Boston, Minneapolis, and elsewhere.

The planners envisioned the ultimate air terminal, with six massive hangars at one end and a row of offices and commercial buildings extending from the terminal building to Sonora Avenue, fronting on an avenue yet to be named Airway (now Air Way). Early in the planning stage, aviation publicist/impresario Victor M. Clark, himself a National Guard pilot, proposed the name Grand Central Air Terminal. The directors voted their unanimous approval.

The Spicer group included Jack Maddux, the Lincoln distributor for Los Angeles. Maddux, a taciturn individualist, had achieved remarkable results as the operator of a recently established airline. Beginning with the purchase of a single Ford trimotor, intended mainly for his own use, Maddux began an experimental passenger service linking Los Angeles with San Diego in July 1927.

Within the year, Maddux Air Lines was providing twice-daily services to San Francisco, San Diego, and the Imperial Valley. Even without a mail subsidy the line was making money, and services were soon extended to Phoenix and El Paso. Maddux, desirous of making Glendale his base of operations, had been a key factor in the development of the airport and an airline that would one day be TWA.

Although Maddux was content to manage the airline and leave the flying to professionals, his wife, who served as traffic manager, became an even more enthusiastic air traveler. Helene Maddux took flying lessons from the line's chief pilot, Capt. D.W. Tomlinson, and joined the newly organized "Ninety-Nines," the international association of women pilots founded by Amelia Earhart. Mrs. Maddux bought a Bird BK biplane identical to one belonging to the Lindberghs, who were friends and frequent house guests. She later operated an airplane sales agency.

The official opening of Grand Central Air Terminal was set for Friday, February 22, 1929. It was a gala affair with Vic Clark serving as master of ceremonies. The film colony turned out in force, several of its luminaries arriving in their own planes. Wallace Beery, piloting his luxurious new Travelair 6000 cabin monoplane, was one; cowboy actor Hoot Gibson was another. *Hell's Angels* leading man Ben Lyon arrived in his own open-air Travelair with actress-wife Bebe Daniels. Gary Cooper was there, and so were Jean Harlow and Howard Hughes.

The celebrity count came to well over 200. Dolores Del Rio headed the welcoming committee. Gov. C. C. Young, flown in by Roscoe Turner, delivered the dedication. An estimated 125,000 Southlanders had a chance to see the very latest planes, both private and commercial. It was a highlight of the aviation social calendar.

Even before the dedication, Curtiss interests had been eyeing Glendale's $3 million airport covetously. The Curtiss-Keys Group, which then controlled the Curtiss Aeroplane and Motor Company and a host of subsidiaries, had just formed the Curtiss Airport Corporation. This enterprise, capitalized at $30 million, quickly gobbled up airports serving Baltimore, New York City, Philadelphia, Louisville, Pittsburgh, Cleveland, Chicago, and San Francisco. The news was not altogether a surprise, therefore, when it became known late in May that the Spicer group had sold out to the Curtiss Airport Corporation.

Captain Spicer became a Curtiss director, as did several of his associates. A month later, a feud that had gone on for decades between the Curtiss interests and the Wrights ended with a merger. Thus, Grand Central Air Terminal became a property of the newly formed Curtiss-Wright Flying Service.

Maj. Corliss C. Moseley, cofounder of Western Air Express and a Maddux director, had been in charge of Curtiss operations in the West since the first of the year. "Mose," no stranger to Glendale, had helped create what is today the Air National Guard and had commanded the 115th Observation Squadron, first at Clover Field, Santa Monica, and later at Griffith Park. Before that, he had been responsible for all air service training. Moseley, a close associate of "Hap" Arnold, had been one of the first pilots to fly combat with the 27th Aero Squadron in 1917 and held numerous citations for conspicuous service. He quickly became the dominant personality at Grand Central and would remain so for nearly four decades.

Grand Central Air Terminal is pictured under construction, with visiting VIPs inspecting the progress. Pictured, from left to right, are flying architect Henry Gogerty, advisor Waldo Waterman, executive committee member Dr. T. C. Young, publicist Vic Clark, advisor Charles Lindbergh, and the first tenant Jack Maddux, whose airline would soon evolve as TWA.

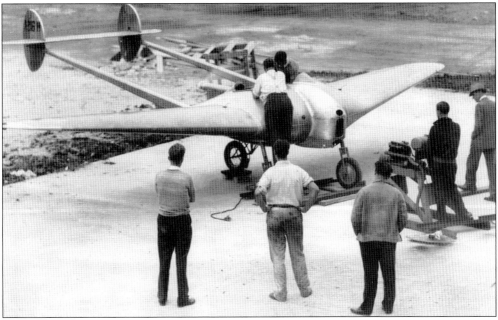

John K. (Jack) Northrop, left foreground, oversees ground testing of his proof-of-concept prototype Avian EX-1, built in a small factory on Glendale's outskirts. JKN envisioned the so-called "flying wing" as the big payload carrier of the future, with the wing carrying its freight and passengers. Eventually, the tail elements would disappear altogether. The EX-1 was the forerunner of the all-wing Northrops of the 1940s and today's F-115 stealth bomber.

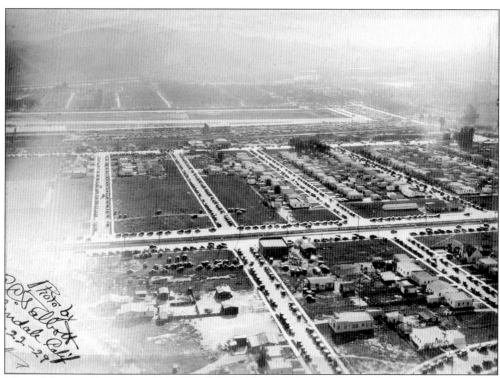

Tens of thousands converged on Glendale for the dedication of Grand Central Air Terminal (GCAT) on February 22, 1929.

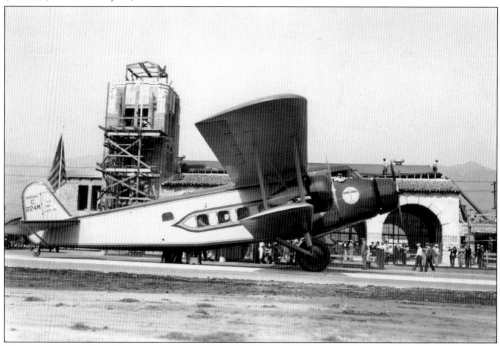

The tower was still under construction when this Boeing 80A arrived for the dedication ceremony with Tom Hamilton and other Boeing executives aboard.

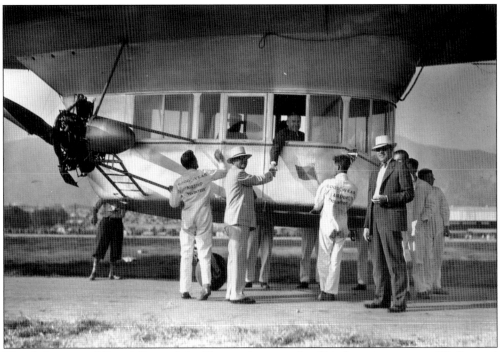

The dedication of Grand Central Air Terminal was a gala affair featuring scores of Hollywood entertainers and numerous other luminaries, among them many great names in aviation. Major Moseley, being greeted by Colonel Spicer, arrived in the Goodyear *Volunteer*.

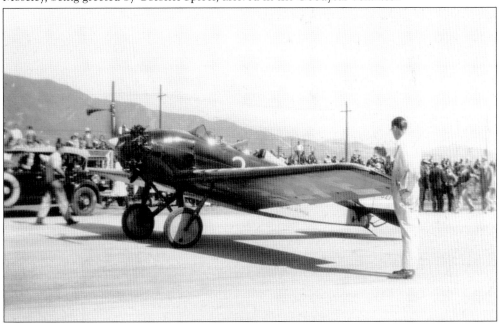

A. L. "Pat" Patterson arrived at the GCAT dedication in the first Mohawk Pinto in Southern California. Its advanced design was placed in production with insufficient testing, and a succession of tragic accidents quickly labeled the Pinto a "killer." By the time the bugs were ironed out, the market had disappeared with the Great Depression.

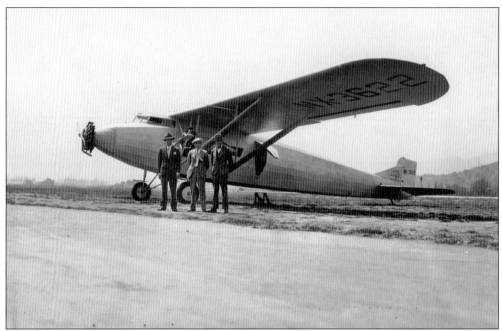

Jimmie Angel, in the cap, whose name belied a predisposition to be otherwise, arrived with the Zenith Albatross, then the largest airplane west of the Rockies. The Albatross proved eminently disappointing, due mainly to engine unreliability, and wound up as a novelty gas station on Ventura Boulevard.

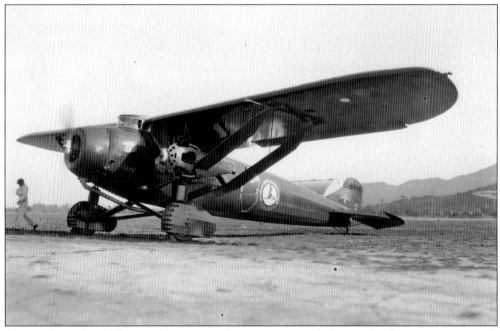

The Emsco B-3 Challenger, X849E, tried to compete with Henry Ford's trimotors, which were excessively noisy and not very fast. E. M. Smith, a successful entrepreneur, invested millions in prototypes that made headlines but little money. X849E ended its days with a Guatemalan airline.

Les Bowman, Kinner's factory serviceman, is pictured with his Fleet 2 demonstrator. Bowman helped perfect the Kinner K5 and demonstrated the engine nationwide. In one demonstration in front of spectators at the Buffalo Airport, a propeller blade flew off and the unbalanced engine wrenched free, plummeting to the runway. Bowman, barely in control, managed to save himself and the airplane.

VIPs exit a Maddux Ford after a sightseeing outing during opening ceremonies on February 22, 1929. Chief pilot D. W. Tomlinson thought his passengers had cleared the loading zone, but they had lingered to chat in his blind spot, despite the churning propellers.

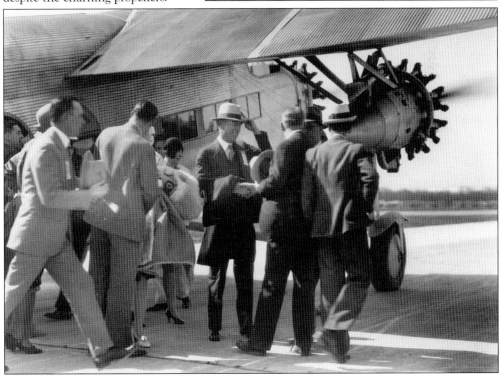

"Tommy" bowls 'em over. Tomlinson, mindful of an approaching trimotor that would be off-loading, poured on the coal, sending bowlers, straw hats, homburgs, and fedoras flying. The big Ford's tail swung around like a scythe, sending the mayor and sundry other VIPs tumbling, including Tomlinson's fiancée. Luckily no one was seriously hurt.

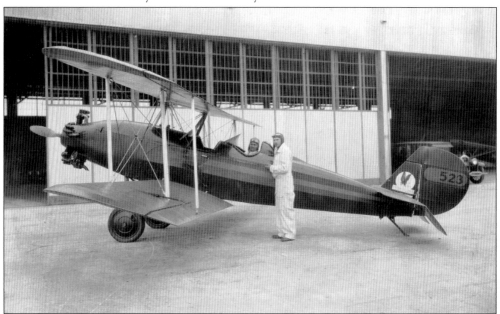

The American Eagle Company of Kansas City became a Kinner customer early on and established its West Coast factory branch at GCAT in 1930. Eddie Angel, at the controls, and Paul Burkhart managed the enterprise. The Model A-129, known as the "Anteater" because of its protracted nose, was sold to a reputed World War I ace and Santa Barbara society figure Johan Pundt, formerly of Kaiser Wilhelm's Luftwaffe.

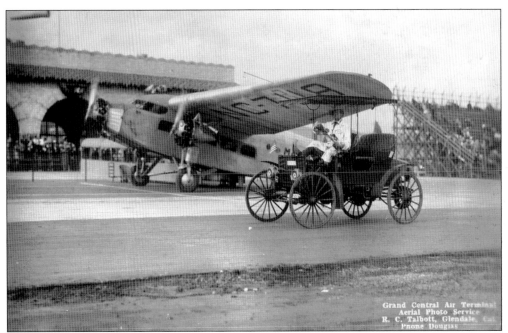

Ray Talbott, who took many of the photographs seen here, showed up for filming sessions in his 1910 Sears and Roebuck automobile. In the background is the Maddux Ford that made dead-stick landings to show spectators that even a big airplane could safely return to earth without the benefit of power.

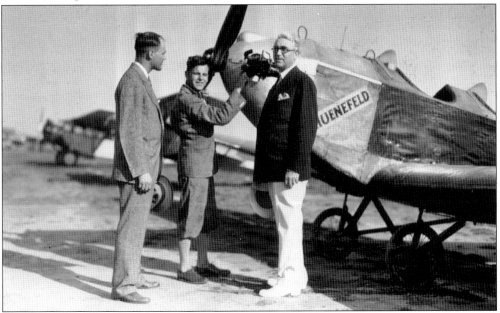

Young Baron Fredrich V. Koenig-Warthausen, having logged 17 hours solo time on his 20-horsepower Daimler-Klemm L20 motorglider, embarked upon a grand tour that took him from Berlin to Tokyo, via Moscow. Freddie took a steamer to San Francisco, then flew on to New York, winning the coveted Hindenburg Prize for spanning 20,000 miles in 450 flying hours. He was greeted at Glendale by TWA's D. W. Tomlinson, left, and Colonel Spicer.

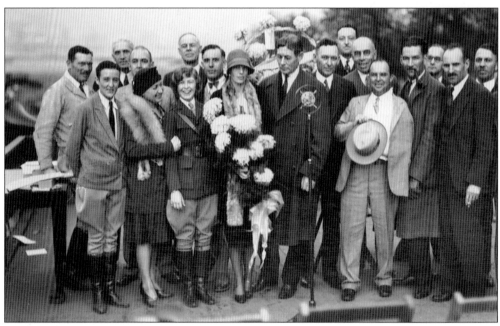

Pictured at the groundbreaking for the Flying Club of California on Sunday, December 8, 1929, from left to right, are Roscoe Turner, Bobbi Trout, unidentified, unidentified, Helene Maddux, Elinor Smith, unidentified, Doneld McDaneld, Amelia Earhart (who did the shoveling), Lt. Gov. H. L. Carnahan, Jack Maddux, publicist Vic Clark, airmail pioneer Earl Ovington, W. E. "Tommy" Thomas of Pacific Airmotive, advisor Waldo Waterman, Glendale mayor C. E. Kimlin, C. S. "Casey" Jones of Curtiss-Wright, and Clover Field manager Rufus Pilcher.

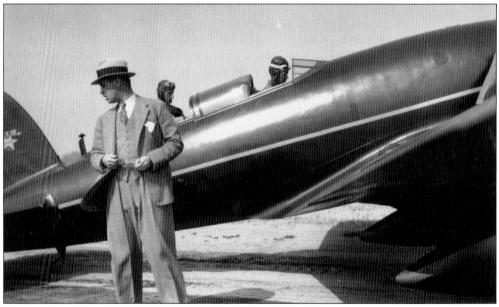

Charles Lindbergh brought his new Lockheed Sirius to Glendale to have its Hamilton steel propeller tweaked a degree or two. The passenger is propeller expert and future Ercoupe designer Fred Weick, nearly eclipsed in the photograph by Tom Hamilton of Hamilton-Standard, Boeing, and other United Aircraft holdings.

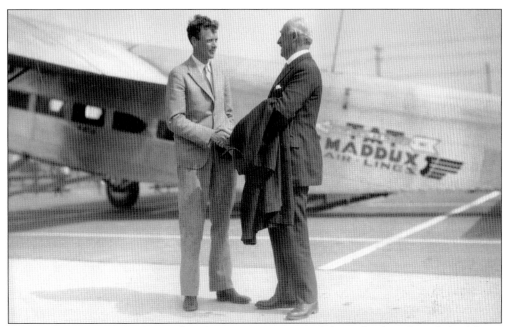

Around March 1930, Charles Lindbergh greets Count Henri de la Vaulx, the acknowledged doyen of air travelers, who was air-touring the planet for Federation Aeronautique Internationale, of which he was a founder and president. The pioneer airman lost his life on April 18, 1930, in a weather-related airline accident returning to New York.

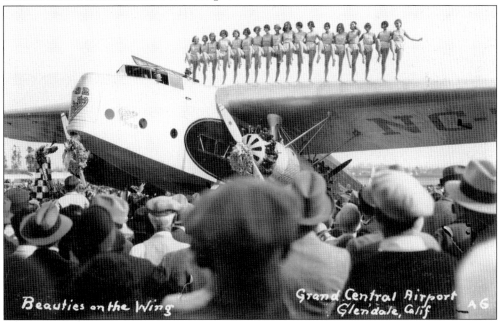

Dancing girls launch the Fokker F-32's inauguration on TWA's coastwise services. The largest airliner in the United States accomodated 32 fares, but most seats remained empty as the Great Depression worsened. The F-32s were retired after two unprofitable years, and NC333N, shown here, spent the next decade as a novelty gas station on Wilshire Boulevard in West Los Angeles before ending its career as a studio prop on RKO's back lot.

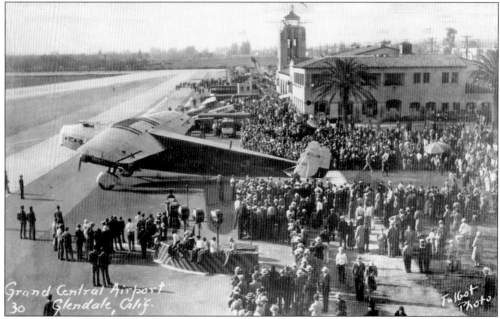

Grand Central Airport 30 Glendale, Calif.

Talbot Photo

The huge Fokker F-32, though impressive for its size, was extravagantly inefficient. Two pairs of tandem-mounted 575-horsepower P&W Hornets, aggregating 2,300 horsepower under ideal conditions. The rear cylinders tended to overheat and occasionally seized. Sometimes bits of disintegrating cylinder would fly through the cabin, but no one was ever injured.

Doc Young's Kinner Courier, the *Spirit of Ether*, newly refurbished by Curtiss-Wright Technical Institute students, appeared at GCAT's second-anniversary air show with a fully enclosed cabin and other refinements. Doc then headed for Palm Springs and a few rounds of golf. Over Chino, he encountered catastrophic turbulence. The wing failed, and the man who had done so much to promote aviation in Southern California became a martyr to the cause.

The stunt-jumping Brown sisters—Jackie, left, and Billy—were popular air show performers throughout the West. Jackie enhanced her fame by stowing away on a Keystone Patrician airliner at Glendale in the mistaken belief that Lindbergh would be the pilot. Lindbergh, who evaluated the plane for TWA, was not aboard.

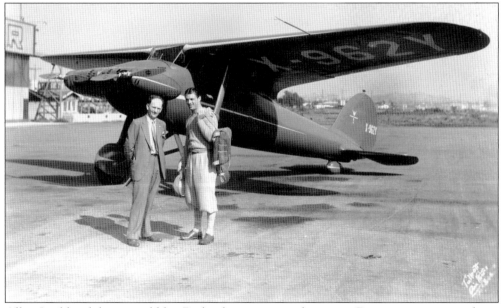

Allan Lockheed, having sold his Burbank company and name to Detroit interests, sought to reestablish himself with a novel, Glendale-built, Vega spin-off called the Olympic (later Alcor) Duo-4 and Duo-6, which featured close-coupled four- and six-cylinder Menascos, respectively. Frank Clarke, best remembered as a movie stunt pilot, was his test pilot.

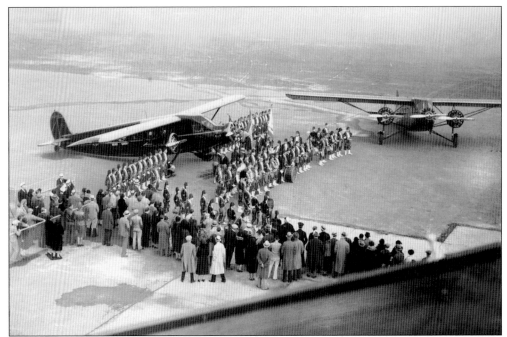

This image depicts the inauguration of automaker E. L. Cord's Glendale-based Century-Pacific Airline in 1931. Cord alienated crews by declaring copilots needless redundancy and offered salary cuts in lieu of pink slips in retaliation for a pilot strike. The newly constituted Air Line Pilots Association had yet to flex its muscles.

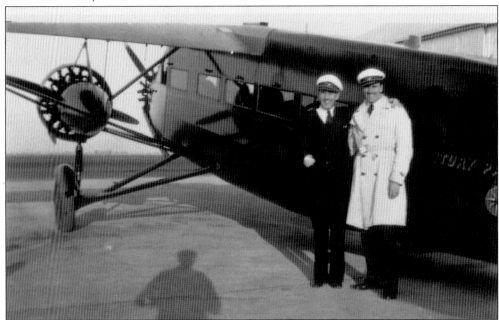

Sterling, left, and Dana Boller started flying as preteens airport "gofers." Both lied about their ages to get into the U.S. Army Air Corps for advanced training. In 1931, they became pilots for Century-Pacific Airlines. The Bollers were deeply involved with Glendale aviation from early on. An elder brother, Vernon, died in a 1929 crash.

Dana Boller plies the Glendale-Bakersfield airway in a Century-Pacific Stinson SM-6000B. The airline provided commuter services to San Diego, San Francisco, and elsewhere.

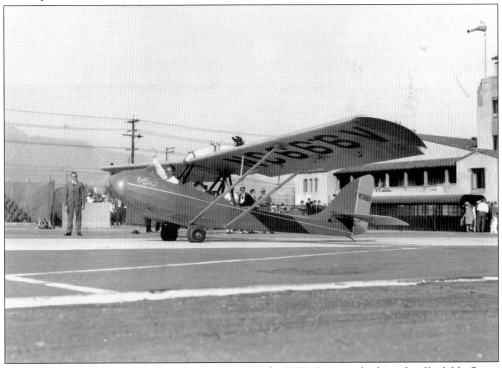

Major "Mose" Moseley is seen here in a Curtiss-Wright CW-1 Junior, which made affordable flying available to tens of thousands of aspiring airmen. Mose once won a slow-speed race around GCAT in the Junior by throttling back and putt-putting along at 25 to 30 miles per hour.

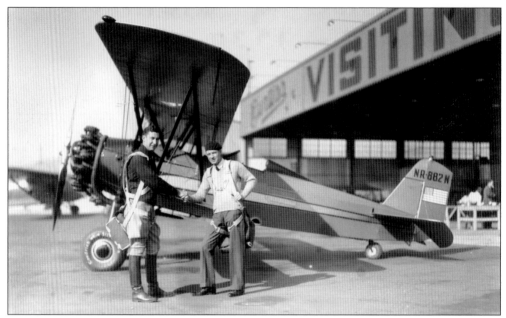

Moye Stephens and Richard Halliburton, the writer and world traveler, are pictured about to embark on a world tour in their Stearman C3B. They visited Egyptian pyramids, Timbuktu, the Taj Mahal, and other fabled places. Halliburton's best-selling *The Flying Carpet* remains a classic. Stephens flew for TWA and helped found the Northrop Corporation as a secretary and test pilot.

Pickwick, later Greyhound Bus Lines, served cities throughout the West and into Latin America, which threatened Pan American's exclusive grip on franchises south of the border. This Ryan B-5 Brougham, a spin-off of the *Spirit of St. Louis*, was a mainstay of the Pickwick fleet. Politics and the Depression killed the enterprise.

Kinner customer Al Mooney, a talented, self-taught aircraft designer, brought his Mooney A-1 to Glendale with the intention of flying it nonstop to the East Coast, but a broken fuel line brought him down in Indiana. The Mooney was sold to a Mexican flier, and Al took a job with Bellanca.

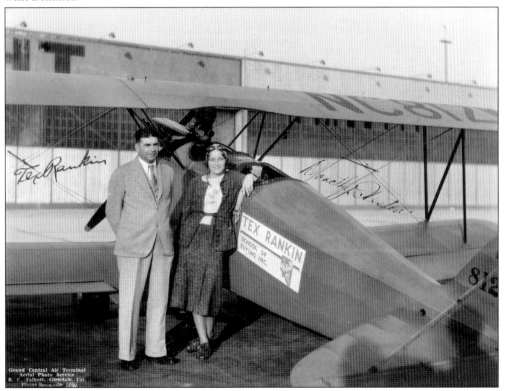

Popular air show performers "Tex" Rankin and Dorothy Hester, respective holders of the inverted loop-the-loop record for men and women, were at the air show in Glendale to celebrate GCAT's second anniversary.

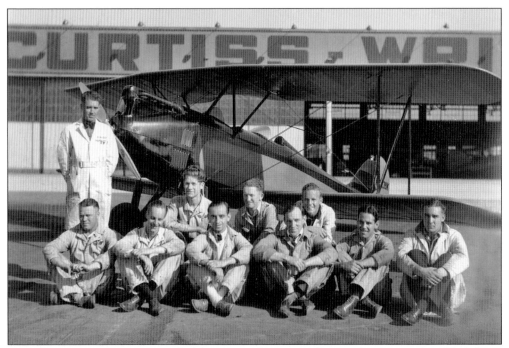

Henry Batson, standing, is pictured with a group of CWTI students with a Great Lakes 2T-1A Sport Trainer borrowed from local distributor George Ruckstell. The airplane, esteemed by exhibition fliers, was so well conceived that it remained in production, off and on, into the 1980s.

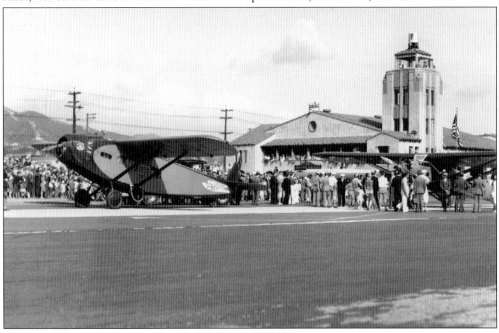

The seven-passenger Pasadena Javelin's debut at GCAT was also its demise. Its makers, including councilman William G. Bonelli, hoped for airline sales, but the Javelin crashed while serving as a refueling tanker to the *Pride of Hollywood* during an endurance record attempt, which became a fiasco witnesed by a crowd of 10,000.

Amelia Earhart looks exhausted from her open-air ordeal, having flown her Pitcairn PCA-2 from coast to coast. A. E. never fully utilized the Pitcairn's vertical capabilities, which resulted in two accidents. The feds tried to ground her after an Abilene, Texas, incident endangered air show bystanders; friends in high office quashed the charges.

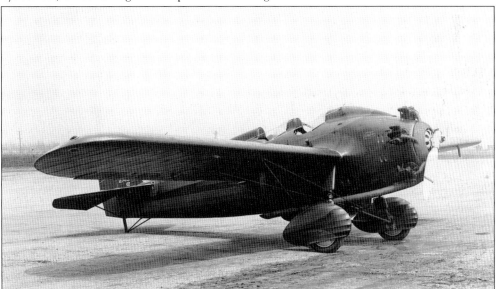

The Emsco B-7 was E. M. Smith's final offering, and it ended tragically at Glendale on a 1931 demonstration hop when its pilot, aviatrix Aileen Miller, lost control on takeoff. Both Miller and her passenger, Yves de Villers, lost their lives.

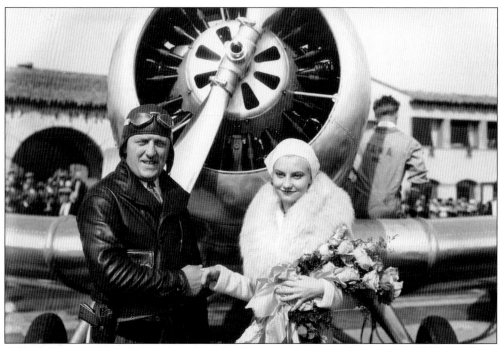

Actress Carmen Barnes is pictured with pilot Bill Coyle at the christening of TWA's Northrop Alpha *Miss Los Angeles*. The Alpha accommodated six fares or the equivalent in mail—1,020 pounds—and cut the transcontinental time to 24 hours.

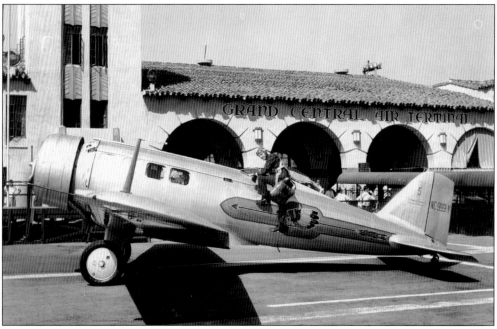

Alton Parker, a former Byrd Arctic expedition pilot, boards TWA's Alpha 5. The Alphas were soon equipped with deicing boots on their wings, thereby taking a step toward all-weather mail flights. Ed Maloney and Company is currently breathing new life into NC999Y at the Planes of Fame Air Museum in Chino.

Part of the Gilpin G&G airline fleet—a pair of Bach 3CT-6 trimotors and a Fairchild 71—is pictured here. NC850E, seen in the foreground with chief pilot Charles Gilpin, was later ditched in the Gulf of California flying a Mazatlan-La Paz service. Seven survivors were seen on the wing, with sharks circling, but when rescuers arrived, there was no trace of anyone. Gilpin himself was killed within months flying a Fairchild 71 on a Mexican charter.

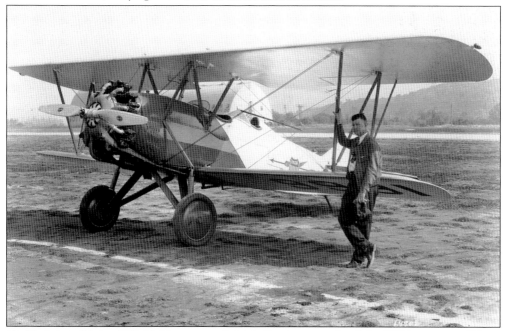

Carl Leinisch, Union Oil's highly esteemed chief pilot, is pictured with his 330-horsepower Wasp-powered Travelair B9-4000, NR9991. The B9 was the most powerful of the open-air Travelairs and the least popular. It was used mainly for skywriting and exhibition flying and was known to be unforgiving.

Johnny Nagel's Travelair S6000B, NC8713, was well known throughout the Southwest. During daylight hours, it transported stretcher cases from one place to another. One night, fog forced its pilot down at Glendale. The next morning, NC8713 was found abandoned on the end of the runway with a load of Mexican hooch. By then, it had been reported stolen.

Ray C. Talbott, a pioneer motion picture cameraman, filmed early 1900s sporting events, including the 1910 Dominguez Air Meet. He moved to Glendale with the opening of Grand Central Air Terminal and is pictured, right, with assistant Merle Oelke, pilot John M. Menafee, their Curtiss Fledgling, and an array of cameras.

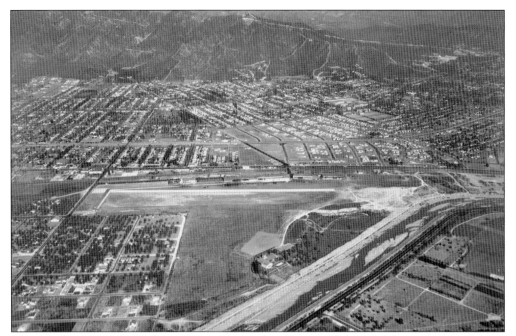

This aerial view of GCAT shows the newly completed Flying Club of California facility adjacent to the Los Angeles River, with its swimming pool and other facilities. Prohibition had yet to be repealed, and secret passageways are said to have provided members with an escape route to the river in the event of a police raid.

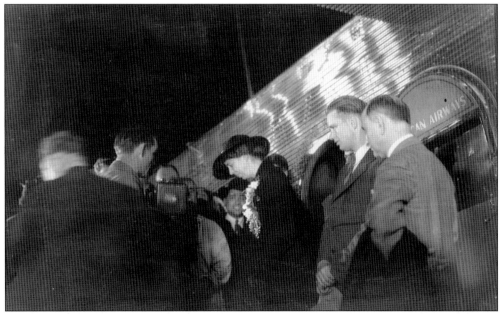

First Lady Eleanor Roosevelt arrived at GCAT in March 1933 to lecture. Her 22-year-old son, Elliott, came to learn the airline business from Gilpin G&G, where he started more or less at the top. Elliott's schooling included flying lessons, and among his first official acts was to schedule services to Caliente, a popular Prohibition-era resort, where he found the nightlife much to his liking.

The Kreutzer K5 was a light, six-passenger trimotor using Kinner 125-horsepower engines. It was popular with Central American bush operations. NC243M operated in Mexico for a time and was repatriated in the late 1930s.

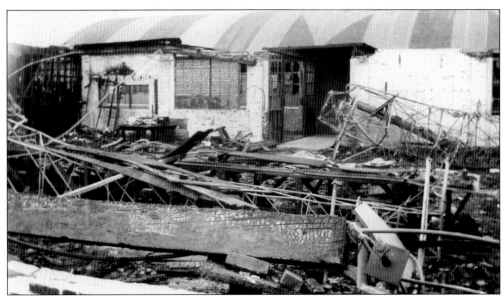

The Air Transport Manufacturing Company, occupying the former Timm factory's twin hangars, had six Kreutzer K5 Air Coaches in production when the adjoining hangar burned to the ground in September 1933. Fire hoses laid on the Southern Pacific tracks were cut by a train. No one had thought to notify the railroad. Howard Hughes rented the back of the remaining hangar to build his racer. The hangar was destroyed in a 1990s fire.

Four

THE NEW DOUGLAS SETS THE PACE

The Douglas DC-1 was undoubtedly the most significant commercial aviation development of the decade. This was the progenitor of the airliner that was to dramatically change the balance sheets of the world's airlines, most of which were operating in the red. Its rollout at Santa Monica was without fanfare, and few outsiders beyond a small party from TWA were present when it took to the air. The occasion—July 1, 1933—left an indelible impression upon everyone present, for the DC-1's first flight was almost its last.

A mix-up in the assembly of the carburetors caused both engines to lose power just after takeoff—first one, then the other. Everyone stood transfixed as the big plane alternately climbed and dived. "My God," someone cried out, "It's going to crash!" It would certainly have crashed had it not been for sporadic bursts of power and the consummate skill of test pilot Carl Cover.

A retractable landing gear was still a novelty, and mishaps were inevitable. On the third flight, someone failed to advise a substitute flight engineer/observer that it was his job to pump down the wheels, a laborious task performed behind the pilot's seat. Fortunately, it was a perfect belly landing and the damage, apart from two severely curled propellers, was minor.

The DC-1's certification, something of a record in itself, was completed in August, and the big Douglas was handed over to TWA during ceremonies at Grand Central. Nine-year-old Barbara Jean Douglas christened it the *City of Los Angeles*, and TWA's D. W. Tomlinson handed her daddy a check for $125,000. For the next year or two and intermittently thereafter, Glendale was the DC-1's home base.

Tomlinson, charged with checking out TWA's senior captains, who would be flying the production model DC-2s, was well pleased with the airplane. It surpassed and, indeed, exceeded all expectations. But one thing about the DC-1 worried Tomlinson. The retractable landing gear, which drew itself into the engine nacelles knee-action fashion on forked struts, was locked down when the hinged drag struts rotated passed dead-center. Hydraulic pressure was supposed to keep it fully extended.

Tomlinson noticed, as had others, that there was an occasional tendency during taxiing for the struts to oscillate away from dead-center. This condition, which Tomlinson described as "limber knees," was more than a little disconcerting to the TWA people. They pleaded with the Santa Monicans to install some sort of mechanical latch to keep the DC-1 from genuflecting inadvertently. The Douglas engineers replied, somewhat pompously, that such a device would be needless redundancy.

The DC-1 was the focal point of an aviation display at Glendale on Sunday, December 17, 1933—the 30th anniversary of Orville Wright's first flight at Kitty Hawk, North Carolina. Among the celebrities present was the modern embodiment of the Flying Dutchman, Tony Fokker, just arrived from Holland. Fokker, whose preeminence as a manufacturer of airliners had ended with the Rockne tragedy, through no fault of his own, had eyes only for the big Douglas.

It was a magnificent airplane, to be sure, and Fokker was pleased with himself for having had the foresight to secure, sight unseen, the exclusive sales rights for Douglas transports in Europe. But even the astute Flying Dutchman could not have envisioned in his wildest dreams the impact the new Douglas would have on commercial aviation. Indeed, who in 1933 could have imagined that its progeny would exceed 12,000?

Tomlinson's apprehensions over the DC-1's "limber knees" were not without foundation. The very next day, he was standing in the cockpit doorway supervising Eddie Bellande's landing. George Rice was in the copilot seat. Bellande, the master airman, wheeled it onto the runway with no more than a chirp from the tires. The airplane was still rolling when Tomlinson, sensing the "limber knees" condition, shouted a warning. It was too late. The crew groaned as one as the big Douglas sank to the ground, its propellers chewing up the tarmac.

There was little anyone could do but vent frustration with some well-chosen expletives.

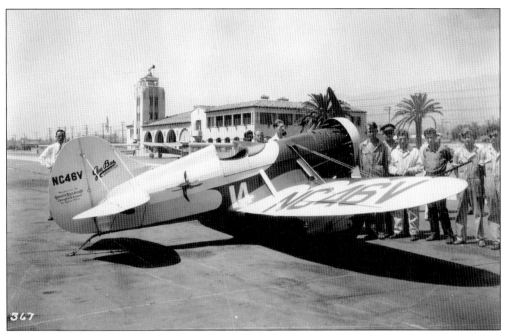

The Gee Bee logo, derived from Granville Brothers Aircraft, was little known on the West Coast when this E-model arrived with its maker, Zanford Granville, at the controls. "Granny" had come to participate in the 1933 National Air Races.

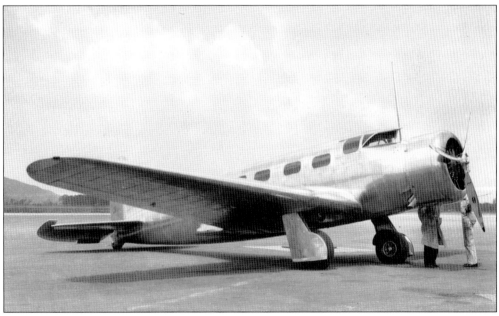

The Airplane Development Corporation of Glendale, bankrolled by automaker E. L. Cord, produced this all-metal airliner, designed by Gerard F. Vultee. Flight testing on what was initially known as the Cord V-1 began in February 1933. An improved model was renamed the Vultee V-1A. Cord's controlling interest in American Airlines resulted in a production order for 10.

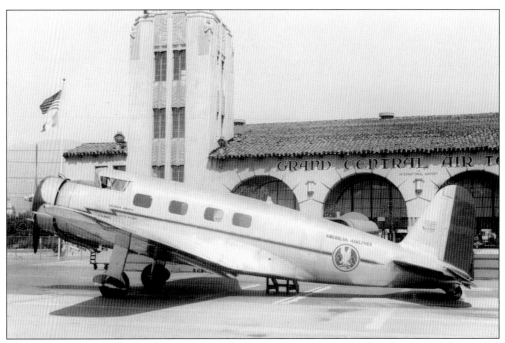

The Vultee V-1A was built almost exclusively for American Airlines. But the days of the single-engine airliner were ending, and the V-1A remained in scheduled service only a couple of years. Several corporate users, including the Hearst publishing interests, bought V-1As, and a number of superannuated AA V-1As ended up as bombers in the Spanish Civil War.

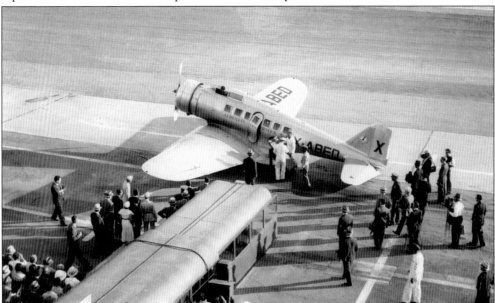

The high-speed, single-engine airliner, pioneered by Lockheed, was in vogue when Northrop Delta entered service in 1934. X-ABED, belonging to Pan Am's Mexican subsidiary, Aerovias Centrales, was short-lived. Sterling Boller was the pilot when an engine fire on the ground destroyed the airplane only days later. Although no one was injured, the incident and others like it sounded the death knell for the single-engine airliner.

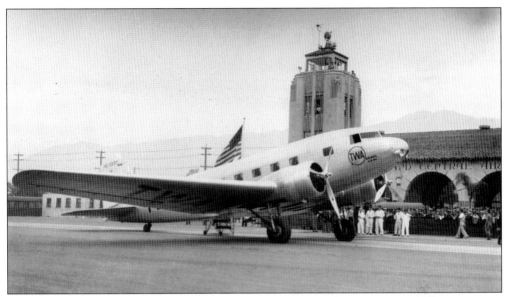

The Douglas DC-1, for all its aesthetic appeal, was very much an experimental proposition. The engines were new, as were the carburetors and the propellers, and its makers were not to be spared a full measure of stressful moments. X-223Y nearly crashed on its first flight when the carburetors malfunctioned. Service testing was carried out from TWA's GCAT base, mostly under Capt. D. W. Tomlinson.

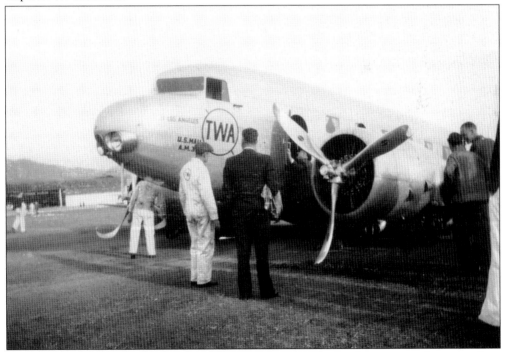

The DC-1's retractable landing gear, brilliantly conceived, had a shortcoming that its makers refused to address—its self-locking feature proved only 95 percent reliable during taxiing. This happened at GCAT while Capt. D. W. Tomlinson was training a new pilot. The problem was not redressed before another embarrassing belly flop in front of a terminal in Kansas City.

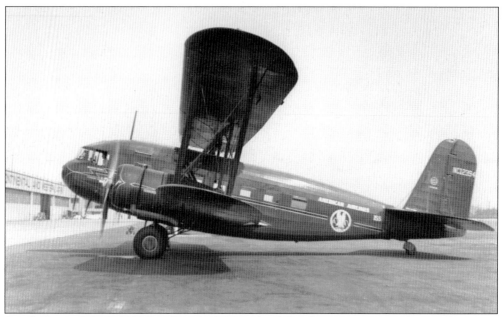

Stately Curtiss-Wright T-32 Condors plied AA's Glendale–El Paso run. AA's "Sleepers" lumbered through the night with a dozen fares in regal slumber. Festooned with bracing wires, a Condor on the approach, with its big Cyclones idling, was a veritable stringed symphony with wings.

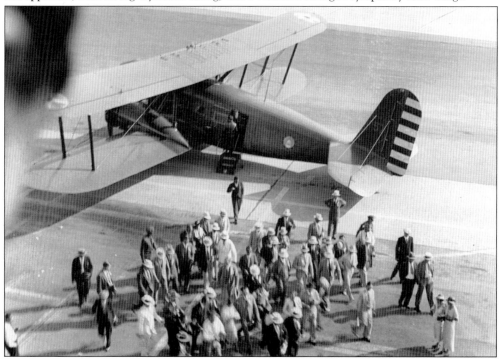

One Condor, detailed to Bolling Field as a presidential transport under the YC-30 designation, was fitted out especially for Pres. Franklin D. Roosevelt, including a folding ramp to accommodate his wheelchair. The nature of this visit to Glendale, viewed from the tower, is unknown and may not have involved Roosevelt.

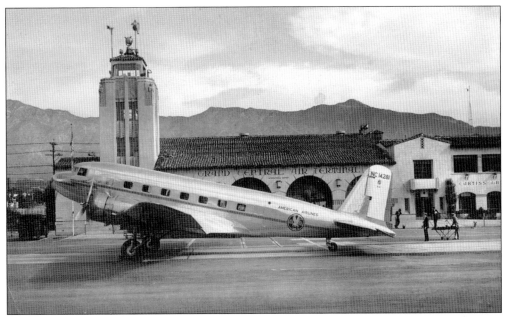

Douglas DC-2, NC14981, served American Airlines faithfully for five years, until it was replaced by the DC-3. Novelist Ernie Gann, who was seasoned on DC-2s as a young AA copilot, recalled that it was a challenge to taxi in a crosswind and was temperamental on landing, with an inclination to gallop; whereas, the DC-3 was docile and forgiving on all counts. To the layperson, one was indistinguishable from the other.

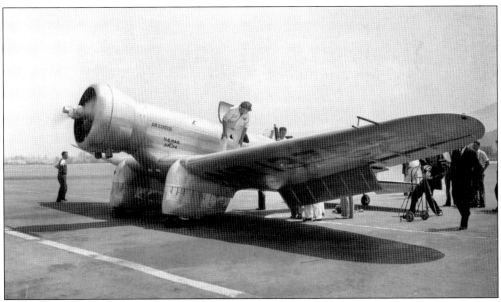

Jack Frye, warms up one of TWA's Northrop Gammas in preparation for a record 11½-hour run to Newark, New Jersey, with 440 pounds of mail and express, on May 13, 1934. TWA's three Gammas, capable of over-weather flying, were used for express mail and all-weather research flying.

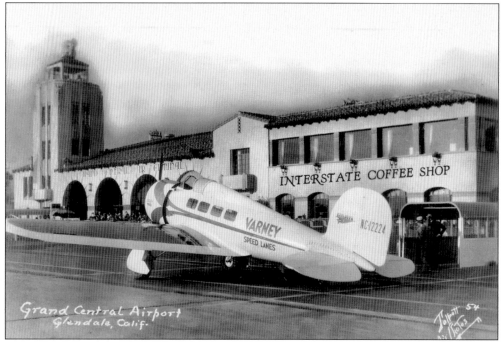

Lockheed's 235-mile-per-hour Orions were the fastest passenger planes in anyone's fleet for years. Varney Speed Line passengers were guaranteed two-hour service between Los Angeles and San Francisco.

The last aircraft to bear Bert Kinner's name was the Model K Sportster. It featured a patented folding wing, later adapted to certain carrier-based naval aircraft. Kinner resigned from the company over management issues, sold his stock, and established Security Aircraft in Downey to produce another engine and a simplified version of the Model K, known as the Airster.

Bert Kinner's lifelong obsession was the perfection of affordable aircraft and engines for the private owner. The single-mindedness of purpose clashed with Kinner Airplane and Motors Corporation's new management under Robert Porter, which led to Kinner's departure. The Kinner P Sedan, built for Porter himself, had the new 210-horsepower Kinner C-5. Only one was built.

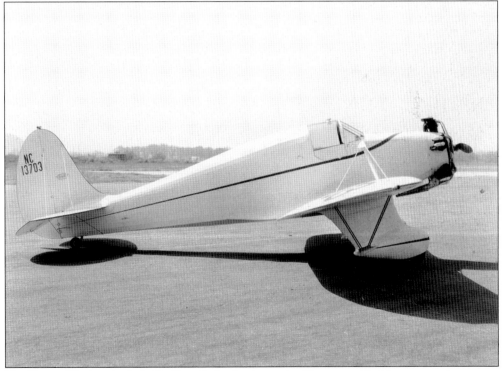

The Kinner Playboy, built for Dr. Ross Sutherland, a major Kinner stockholder, was an elegant two seater with the 160-horsepower Kinner R-5. Five were ordered by the Department of Commerce for CAA inspectors in the field. The Sportwing was a companion model with open cockpits.

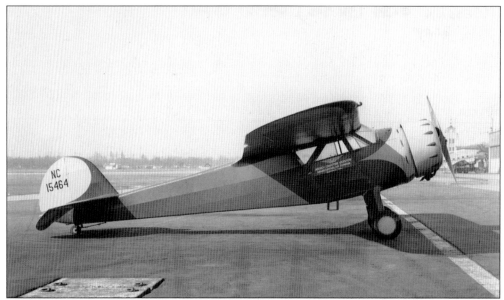

One of the few light plane builders to weather the Great Depression was Cessna, which had manufactured a successful four seater known as the AW in the late 1920s. The company, after a period of dormancy, resumed production with the Model C-34 Airmaster, which won the lightplane efficiency competition at the 1935 National Air Races. NC15464, the first Airmaster on the West Coast, joined the GCAT lineup with Arney's Charter Service.

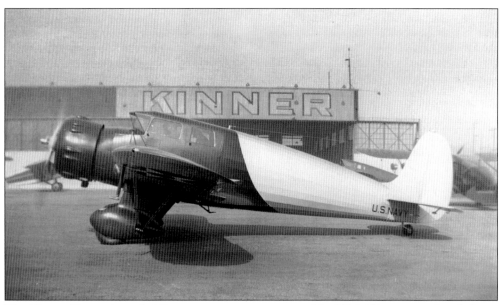

The Kinner Envoy, intended for corporate users, appeared in 1934. The navy ordered three, including this one for Adm. Ernest J. King, chief of the U.S. Navy Bureau of Aeronautics. The Kinner Company went broke attempting to develop a 1,000-horsepower, 14-cylinder, twin-row radial for the navy. Robert Porter resigned, and the company reorganized with an RFC loan and new management to have a role in wartime engine production for the United States and its allies.

Hawley Bowlus, right, is pictured with Warren Eaton, seated in his custom-built Bowlus sailplane, built largely by CWTI students. Richard Du Pont, left, was a pioneer soaring enthusiast who lost his life testing a huge experimental assault glider during World War II. A frequent Glendale visitor, Du Pont owned an elegant metallic gold Kinner Sportwing.

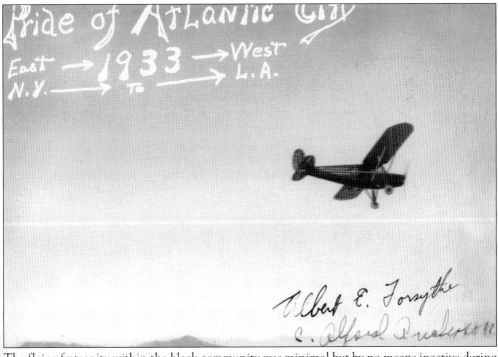

The flying fraternity within the black community was minimal but by no means inactive during the Depression. This Fairchild 24C8, the first of its series, belonged to Dr. Albert Forsythe, a New Jersey physician who, with C. Alfred "Chief" Anderson, made a newsworthy coast-to-coast and return flight on behalf of the National Negro Aeronautical Society.

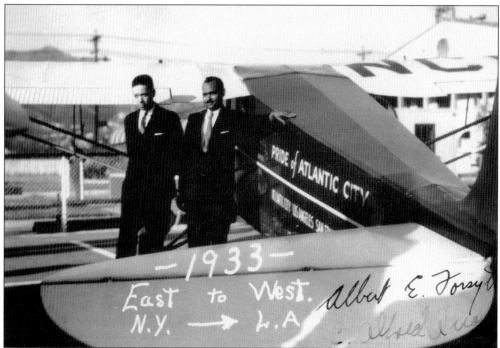

"Chief" Anderson, left, and Dr. Albert E. Forsythe are seen beside the Fairchild 24C8, then little known on the West Coast. The Forsythe-Anderson transcontinental flight promoted the Fairchild, which was popular years later in three- and four-passenger models. Anderson was Eleanor Roosevelt's pilot on her 1941 visit to Tuskegee Institute, which was about to train the first African American airmen for the U.S. Army Air Corps.

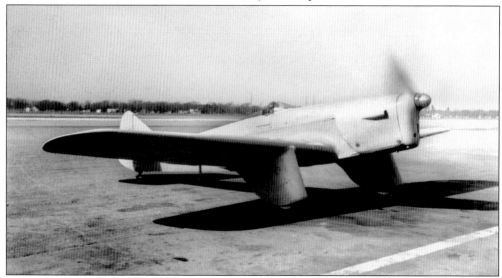

Attorney J. H. "Jimmy" Smith, future secretary of the U.S. Air Force, imported this Miles M5A Sparrowhawk, NC191M, while stationed in England, facilitating an exclusive transatlantic franchise for Pan American. Smith, a former navy pilot, liked to regale friends with stories of how he was fledged as a teenager by Charles Lindbergh in a "Jenny." The Sparrowhawk was domiciled at GCAT during the winter of 1936.

Five

THE 350-MILES-PER HOUR-OR-BUST CLUB

Speed-oriented Southern California became a mecca to the air-racing fraternity. The big impetus had come from the 1928 National Air Races, staged at Mines Field under the able management of the brothers Henderson, Cliff and Phil. The weeklong extravaganza had drawn huge crowds and elicited enormous sums in prize money. The public demanded more of the same, and the lure of big-time air racing precipitated a boom in the building of aircraft designed for speed alone.

Grand Central Air Terminal had a share in this activity, thanks to Howard Hughes's determination to own the world's fastest landplane. Toward that end, he rented a garage on San Fernando Road, near GCAT, and staffed it with a dozen of the best and the brightest young designers and technicians. Dick Palmer, Vultee's chief engineer, was recruited to head a team composed mainly of Cal Tech grads. Working in secrecy, they produced a design labeled the "Palmer Special" to conceal its true identity. A half-scale model showed great promise when tested in the Cal Tech wind tunnel.

The airplane itself was built in the back of Babb's hanger at 911 Airway, where secrecy was eventually compromised. The public became aware that Hollywood's favorite playboy-filmmaker was spending upwards of $150,000 on an airplane intended for a shot at the world's record. Its 700-horsepower Pratt and Whitney Twin-Row Wasp was rumored to be capable of 1,000 horsepower on doped fuel.

Testing at Glendale was out of the question, due to airline traffic constraints and population density. Mines Field, with its 4,000-foot runways, had little traffic, and its environs were still mostly under cultivation and sparsely populated. Hughes had the airplane registered in the racing category as the Hughes Model A, NR258Y, and trucked it to Mines for testing.

Hughes had prepared himself for the occasion by acquiring a Beechcraft of the A17R genre, which was fast and tricky. It was said of the A17F that a pilot who mastered it could handle anything. Despite a few worrisome moments, due to a propeller malfunction on one flight and a stuck landing gear on another, Hughes found the "A" much to his liking. Four weeks later, flying from the Martin brothers' field at Santa Ana, Hughes established a landplane speed record of 352.388 miles per hour.

Major Moseley, himself a former holder of the world's speed record, having won the Pulitzer Trophy in 1920, encouraged further racer activity by making the facilities of the Curtiss-Wright Technical Institute available when a project seemed to have merit. "Mose" believed his students would benefit from exposure to the research and development necessary in the creation of racing aircraft. The Burrows R5, designed by Riley Burrows, was the first of several such projects.

Meanwhile, designer Keith Rider had thrown in with Story-Gawley Propellers on Airway to build the Rider R-6. A designer since 1916, Rider had produced several racing planes that had fared well over the years, earning for their owners an enviable share of prize money. The R-6 featured a molded plywood fuselage, a new approach to making durable, rot-resistant airplanes out of wood. Rider would later apply these methods to the construction of training aircraft for the military.

Elsewhere in Glendale, Harry Crosby was formulating the C6R3, patterned along the lines of flying fish he had observed while returning from Guatemala on a banana boat. Crosby was convinced that nature had endowed the little creatures with the correct profile for optimum speed, both in the water and out. Domiciled at the Glendale YMCA to save money, he enlisted financial aid from a wealthy pilot friend, Keith Scott.

The C6R3 was built under the supervision of Burchard Wilson, head of CWTI's sheet-metal department, with volunteer labor. Everyone was anxious to have a hand in the enterprise, which became a kind of cottage industry with Wilson's garage as final assembly. Complex machined parts, such as landing-gear members, were made by students in the school's shop. Small sheet-metal fittings and such were produced in home workshops.

The C6R3, registered R260Y, was tested five days ahead of the 90-day completion schedule, just in time to make its debut at the 1936 National Air Races at Mines Field. Although the spinner and canopy were unfinished, R260Y was perceived to be a 300-miles-per-hour-plus airplane. Its unfinished state penalized performance, however, and minor problems during the Thompson Trophy Race made for disappointing results. Crosby finished the event in sixth place, pocketing $850 for the effort.

Seeking to better the mark set by Howard Hughes, Crosby made several practice runs over a measured 10-kilometer course, reputedly exceeding 300 miles per hour. His official run, on Armistice Day, 1936, ended when his 260-horsepower Menasco Super Buccaneer quit. Crosby crash-landed the C6R3 in the Tujunga Wash, nearly killing himself. He was rushed to the hospital with a broken back and fractured skull.

Undaunted, Crosby began designing an improved model in the hospital, flat on his back. This was the CR-4. He was broke again, but Scott came up with the money to build a completely new airplane, using the salvaged Menasco. Once again, volunteer labor was recruited from the CWTI student body. Engineering and construction was carried out as classroom exercises, with Major Moseley's blessing.

Crosby was released from the hospital in April 1937 and took a job selling used cars until he was out of the body cast. He then eloped to Las Vegas in a borrowed Travelair 12W with a pretty brunette named Betty Pankratz. He was soon flying charters again in an old Fokker Super-U, albeit an inch shorter from the spinal trauma.

The CR-4, completed in April 1938 and bearing the registration NX92Y, was trucked to Mines Field for testing. Severe aileron flutter occurred on the first hop, and Crosby landed heavily. One wheel collapsed, and the CR-4 pirouetted to a standstill on a wingtip. NX92Y was repaired in time for the NAR at Cleveland in September, but an engine fire necessitated a dramatic dead-stick landing. Harry's trousers were scorched, but he was otherwise unharmed.

Crosby's crew worked around the clock to have the CR-4 ready for the Thompson Trophy Race the next day, but once again he was forced to make an emergency landing, nearly overcome by fumes from leaking fuel. Another minute or two and NX92Y would have plunged from the sky in flames.

The CR-4 was back in the starting lineup in 1939, but teething troubles remained unresolved. The wheels failed to retract during the Greve Trophy race because the compressed air tank had emptied. Crosby was flagged down on the 14th lap and credited with third place. Two days later, he had engine trouble in the featured Thompson event and finished fourth. Once again, he was "Hard Luck Harry" to the oddsmakers.

The onset of World War II, already raging in Poland as the 1939 program opened, marked the end of Grand Central Air Terminal's dalliance with the National Air Races.

The Crusader AG-4 was designed by Tom Shelton, who brought it to GCAT from Denver. Its futuristic design foretold the shape of fighters to come. Howard Hughes reportedly offered a generous $25,000 for the Crusader, but Sheldon declined on account of ongoing negotiations with prospective manufacturers, including the Timms. The twin-boom concept was adopted by Hughes for his D4/XF-11 fighter projects and by Lockheed for the P-38.

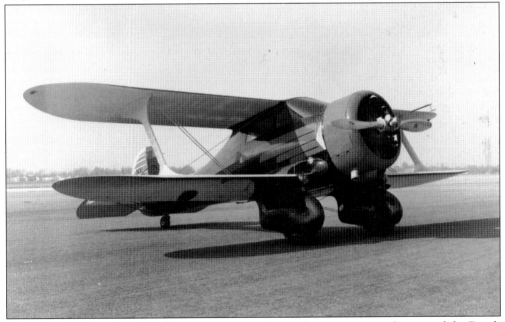

Hughes, seeking to avail himself of an airplane with record-setting potential, acquired the Beech A17F, which was akin to holding a tiger by the tail. It was a fast airplane and demanded the utmost skill, which proved to be good training for Hughes, whose ambition was to create the fastest landplane in the world.

Wiley Post and Charlie Babb pose with Post's ill-fated hybrid Lockheed, assembled from components salvaged by Babb's company. Lockheed disapproved of the mating of a mismatched wing to an Orion fuselage and the installation of pontoons. Post's inexperience with seaplanes resulted in the tragic 1935 crash at Point Barrow, Alaska, that also took the life of beloved humorist Will Rogers.

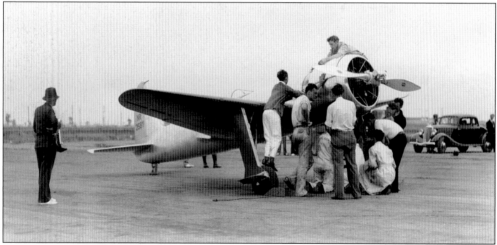

Howard R. Hughes's racer is being readied for its first test flight by a crew comprising the best and brightest Cal Tech graduates. NR258Y flew initially as the Hughes Model A with a 25-foot wing and as the Model B with a 32-foot wing. The prevailing "H-1" designation was a media invention deplored by Hughes.

Friday, September 13, 1935: Superstition does not seem to have been a part of the Hughes character. R. C. Talbott's photo finish shows Hughes crossing the wire to establish a new World's Landplane Speed Record of 352.388 miles per hour. He could have landed but continued making speed runs until his fuel was exhausted, necessitating a crash landing in a beet field that severely damaged the airplane.

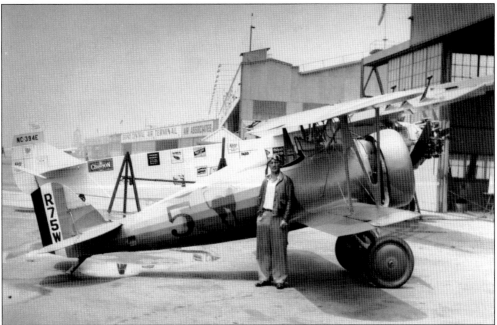

Garland Lincoln had an arsenal of vintage warplanes employed in movie work. He is pictured here with one of several replica 1917 Nieuports he built himself, which had fighter-like maneuverability. They embodied modern construction and engines.

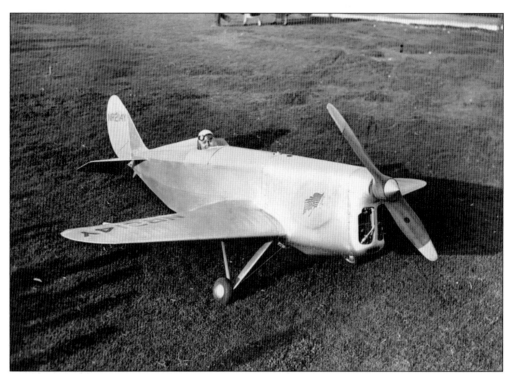

The Burrows R5 Special, designed for pylon racing, became a CWTI classroom project in an effort to enhance its range and performance. Although the cockpit looked small on the outside, it was sufficiently commodious to fit its 235-pound designer-pilot, Riley Burrows.

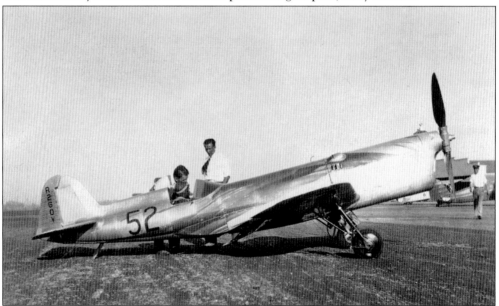

Harry Crosby's C6R3 Special, profiled along the lines of a flying fish, had the pilot in a supine position to keep the fuselage as streamlined as possible. The project was engineered and constructed by CWTI student labor. Unfinished refinements, such as the propeller spinner, wheel fairings, and cockpit canopy, penalized its performance at the 1936 National Air Races.

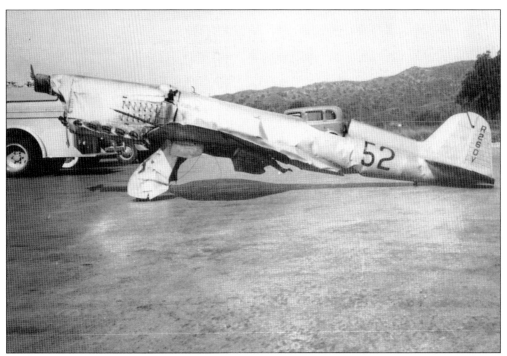

Bent and twisted, the remains of the C6R3 are pictured here after the engine quit while Crosby attempted a world speed record. The crash broke his back and nearly blinded him in one eye.

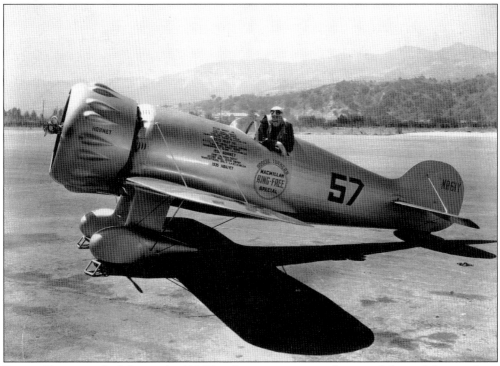

Roscoe Turner crashed during the 1936 Bendix transcontinental race and shipped the wreckage of his Wedell-Williams 57 to Glendale for rebuilding by the Timms.

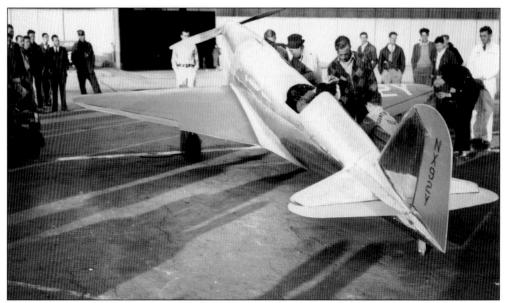

While recuperating from crash injuries, Harry Crosby designed the CR4. It, too, was built by student labor. Perceived to be a 300-mile-per-hour-plus airplane, it had bad racing luck.

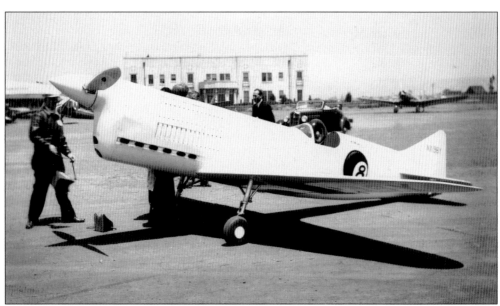

No photographs are believed to exist of Keith Rider's R-8 *Eight Ball* at GCAT. It was only built there but was tested elsewhere. Here the *Eight Ball* is pictured at its racing debut at Oakland in 1938. Rider later applied lessons learned from the R-8 to another Glendale design, which evolved as the Timm N2N trainer for the navy.

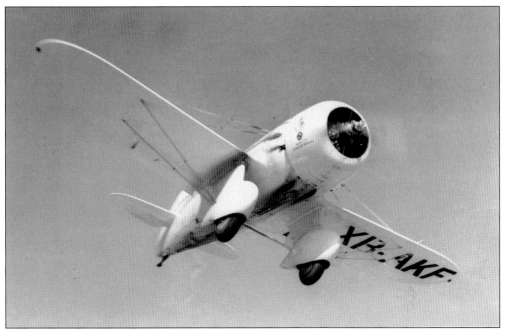

Charlie Babb's stock-in-trade was mainly workhorse craft, but he occasionally bought and sold racing specials. This one, the last of the fast and infamous Gee Bees, was sold to Francisco Sarabia, a Mexican airline owner, who met a tragic end in the waters of the Potomac attempting a record flight to Mexico City.

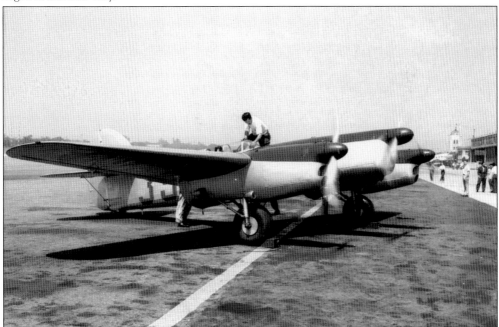

The Bellanca 28-92 trimotor, propelled by a pair of 250-horsepower Menascos outboard and a 400-horsepower Ranger V12, had been conceived for a transatlantic race that never came off. It fared well in the 1939 Bendix, piloted by Art Bussy, finishing second at just over 244 miles per hour. Babb later sold the Bellanca to the government of Argentina for military purposes.

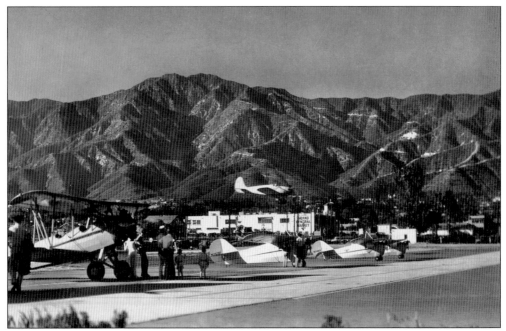

The Plosserville fleet included the Curtiss-Wright 16K instrument trainer in the foreground and a trio of "bathtub" Aeronca C3s, for which Plosser was the Southern California distributor. All eyes seem to be on the approaching Kinner Sportster, whose pilot must be making his first solo.

Plosserville-instructing aviatrix Evelyn Hudson is pictured here flanked by Joe Plosser, left, and Ted Ellis of the Seaside Oil Company with the Aeronca C3, NC15287, in which she established a new solo refueling endurance record of 33 hours, nine minutes. Evelyn refueled by snatching a two-gallon can of gas 44 times from Joe, stationed in the rumble seat of a speeding roadster. During World War II, she ferried bombers in England with the Air Transport Auxiliary. Evelyn married one of her students and gave up flying to raise her sons.

Six

PLOSSERVILLE

In the beginning, when Colonel Spicer and company were running things, it was decreed that Glendale airspace must not be cluttered with the comings and goings of flying school students. An air terminal was expected to be far too busy a place for fledglings. Later, when Major Moseley took charge, the "no schools" ban was lifted to the extent that a single operator was permitted. Flying instruction was available for a time from the Curtiss-Wright Flying Service as an adjunct to courses offered by the Curtiss-Wright Technical Institute. Later the school was operated as a concession. Hal Speer had it for a time, operating a single open-cockpit Aeronca C3 Collegian. Speer gave it up to go with an airline.

Joe Plosser, a Century-Pacific pilot based at Glendale, found himself out of a job in the spring of 1932 when E. L. Cord sold out to American Airlines. Most of Cord's pilots went with American, which was Chicago-based, but Joe had promised his family that they would not have to move again. The Plossers were settled in Glendale and were going to stay. Plosser freelanced for a couple of months, then went with Moseley as chief pilot for the CWFS. The company operated a Ford trimotor, which was employed mainly for sightseeing. Piloting 10-minute joyrides was good practice for landings and takeoffs, but it became terribly monotonous. Joe was ready to try something else.

Plosser had been offered the flight school concession, but he had misgivings about resuming a career thrust upon him in 1918 when he and a classmate, Jimmy Doolittle, had been chafing to get overseas. Both had been mightily chagrined to be posted to San Diego's Rockwell Field as air service flight instructors.

Still, the offer "Mose" had made was too good to pass up. A tie-in with CWTI practically guaranteed steady business. In September 1932, Plosser and a partner, Phil Filloon, formed the Grand Central Flying School, bought a secondhand Curtiss Fledgling and signed up their first pupil. The GCFS was no overnight success story, and Filloon sold out within the year. Things picked up, and by mid-1934 Plosser had four planes, including one of the few instrument trainers in the area. All airline captains had to be instrument-rated, and some airlines were requiring the same of copilots. Plosser's Travelair 16E was always busy. Very often, the pupil under the hood was a celebrity. Wallace Beery took instrument training from Plosser, as did aviatrix Laura Ingalls and Howard Hughes. Even Doolittle, who had pioneered the art, came to Joe to renew his ticket.

Plosser's biggest problem was keeping instructors. Eventually, they all went with the airlines. Early in 1936, he lost two, one after the other. Burleigh Putnam, who had little previous experience, was hired on the basis of his eagerness to learn. He learned quickly and logged 800 hours of instrument time in just 18 months.

Howard Hughes was one of Putnam's students; so was Douglas Corrigan, who had yet to earn his "Wrong Way" nickname. Everybody knew that Corrigan had loaded his venerable Robin up with fuel tanks, but no one dreamed he would try to fly it to Ireland. Hughes was by far the sharpest pilot with whom Putnam ever flew. He had memorized the frequencies and leg headings of every radio range in the entire United States. Every so often, Hughes borrowed Putnam's Model A roadster. It was always returned freshly washed and polished, with a full tank of gas.

Plosser's success was largely due to a systematic way of doing things. He was a stickler for punctuality, and woe unto the instructor who was not present for the 7:00 a.m. briefing, with his plane serviced and on the line at the stroke of eight. Every student's progress was carefully charted, and any evidence of bad technique was addressed at once. The GCSF was government certified and approved for all ratings up to and including the coveted air transport license, and it ranked with the finest training facilities anywhere in the country.

By 1936, the northwest corner of Grand Central Air Terminal had come to be known as "Plosserville." Sideline enterprises were beginning to flourish. A charter business, later to function separately as the Aero Transport Corporation (the ancestral beginnings of Pacific Southwest Airlines), began with a contract to supply a Fox Studios crew on location in Death Valley.

Plosser had been appointed the Aeronca distributor for California. The squat little Aeronca C3, a two-seater of comic proportions, was sprightly and economical to operate. Priced at $1,995, it was second only to the J2 Cub in popularity. Joe sold about one a month when the Deluxe, fully enclosed model was introduced.

The C3 was soon supplemented by the elegant and racy low-wing Aeronca LA, which had tricky ways and was short-lived. Two young hot-shots downed a few beers and went joyriding in Plosser's demonstrator. Joe would never have rented them the airplane had he known they had been drinking. They did a buzz job too close to the ground, with tragic consequences.

The acquisition of a Lockheed Orion 9 in the latter part of 1936 greatly enhanced Plosser's position as a charter operator. An Orion operator could still provide faster service anywhere. One of Plosser's first trips in the Orion was an elopement to Yuma, Arizona, which made front-page news. His clients were John Barrymore and Elaine Barrie. The Orion had a habit of breaking throttles, however, and this led to Burleigh Putnam's forced landing on a beach beside the Salton Sea. While the Orion was awaiting repairs, a gentle wind rocked its wings enough to make the wheels settle into the soft sand. When Putnam returned it was flat on its belly.

Plosser traded the Orion to Charlie Babb for a Lockheed Vega 5C, which required less maintenance and was only slightly slower. A Stinson SR8BM Reliant was acquired at the same time and outfitted for quick conversion as an air ambulance. Pilot Tommy Winfield and the Vega were detailed to Death Valley to take advantage of the winter tourist trade. The Vega was kept busy flying sightseers and did good work seeking out and supplying high-desert dwellers isolated by the January blizzards.

Plosser's Aero Transport Corporation added scheduled services to Del Mar with the opening of the 1937 racing season, operating up to four round-trips daily. A leased Lockheed 12 was soon added to the fleet. Aeronca sales gained steadily with the introduction of the new K-series and Plosser appointed Jack Beilby to represent the company in the San Francisco Bay area. Late in 1937, he extended his operations to Oxnard and Pomona by taking over the management of both airports. Satellite schools were operated at both locations according to the requirements of the season.

Plosser's old Stinson "O" instrument trainer was kept busy, often for eight hours a day, training pilots in the art of "flying blind." Plosserville was, at this time, the foremost instrument flying school in the West.

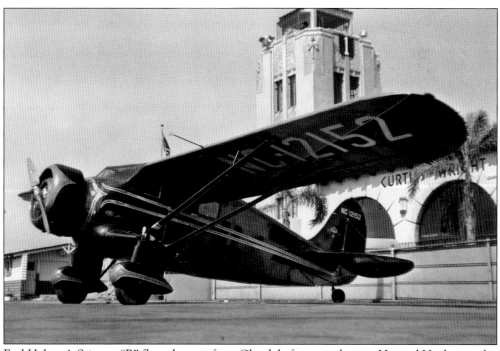

Earl Hobson's Stinson "R" flew charters from Glendale for several years. Howard Hughes used it for cross-country flying on numerous occasions.

Wallace Beery, who won an Academy Award for *The Champ* (1931) and starred in dozens of films, is seen here regaling youths with tales of aerial escapades. Beery took up flying in 1928, to the horror of studio moguls. Efforts to ground him failed, and he averaged a new plane purchase per year. Beery liked giving joyrides to disadvantaged youngsters.

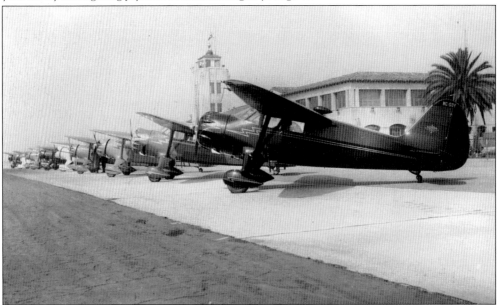

A lineup of Stinsons sold by Major Moseley's Aircraft Industries, Inc., is pictured with, in the foreground, Wallace Beery's new Whirlwind-powered SR9E Reliant, NC50Y, outfitted with special doors for easier access and a folding bed.

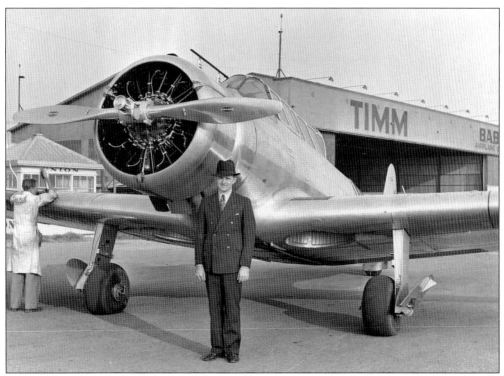

Jerry Vultee's chief test pilot, John I. Wagner, poses with the new Vultee V-11 attack airplane. Wagner, who had flown throughout South America for Pan American Airlines, took a demonstrator to Brazil and booked an order for 25. Export orders from China, the USSR, and Turkey kept the company viable during the 1930s.

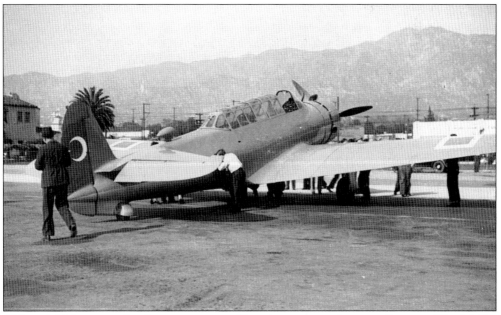

Although Vultee moved to larger quarters in Downey, export orders were flown to Glendale for sea shipment by the Babb Company. This is one of 40 V-11s ordered for the Turkish Air Force.

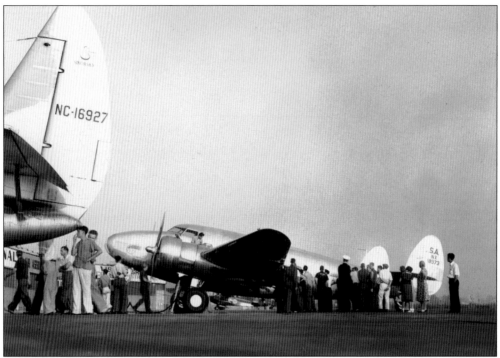

The arrival of Howard Hughes in his Lockheed 14N2 Super Electra on August 1, 1938, drew a huge crowd. He had just circumnavigated the planet in 91 hours, establishing a new record.

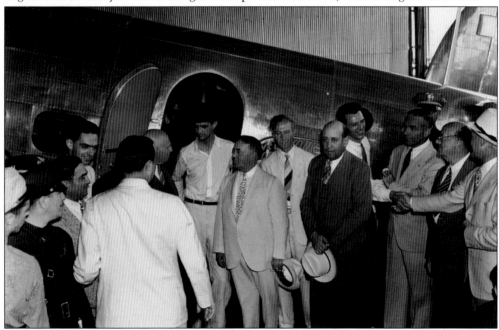

The Hughes world flight crew is greeted by local politicians and Major Moseley, partly eclipsing the cop near the tail. The smiling figure three heads to the left of Howard Hughes is copilot/flight engineer Ed Lund, a Hughes look-alike who often doubled for his boss at press conferences. Lund later managed Babb's brokerage operations in the East.

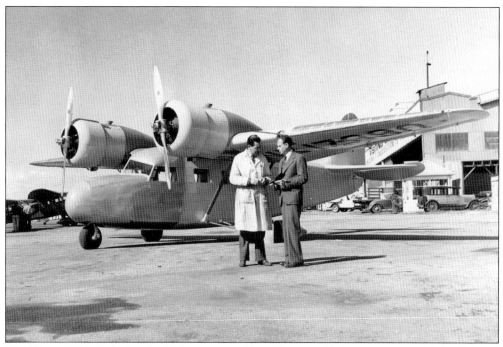

The Timm T-840 is depicted with its designer, Otto Timm, right. Timm anticipated the demand for a light twin-engine business aircraft with tricycle landing gear a full decade before the popular Aero Commander dominated the market. But he lacked the finances for production.

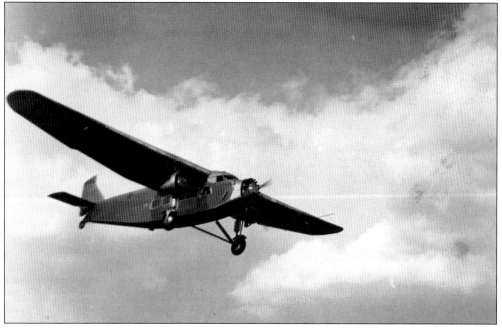

Messrs. Reed and Clem domiciled their barnstorming/sightseeing Ford 4AT, NC5578, for years at GCAT. While landing at Burbank after a nighttime Warner Brothers film shoot, the Ford collided with an unlit power pole on the approach, blacking out half of Glendale. Pilot Howard Batt managed a safe landing with a seven-foot section of pole impaled on the trimotor's nose.

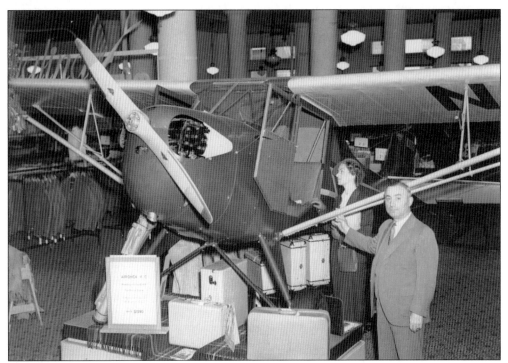

The Aeronca KC was a decided improvement over the comical "bathtub" C3. Joe Plosser had one put on display at the May Company and detailed Evelyn Hudson to encourage shoppers, especially the ladies, to visit "Plosserville" for a free demonstration. She is shown here inspecting the display with a manager before opening time.

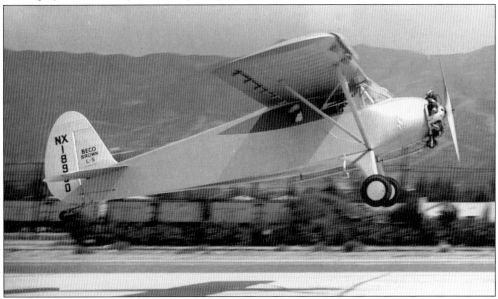

Inventor Harvey Beilgard's Beco-Brown L-5 embodied all the latest features, including automatic slots and flaps that permitted STOL-type performance. It was fueled with butane and was said to cost less than 20¢ per hour to fly. Beilgard, a teenage assistant to Octave Chanute, built his first plane in 1910.

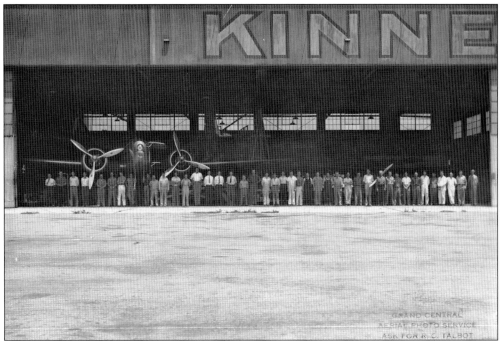

Occupying the former Kinner hangar, the Hughes crew is seen with the Lockheed 14N2 Super Electra. Barely visible in the background is the Sikorsky S-43H, elevated to make room. On the right is Hughes's little Stinson 10, NC26274, used for running errands and joyriding with girlfriends, several of whom he taught to fly.

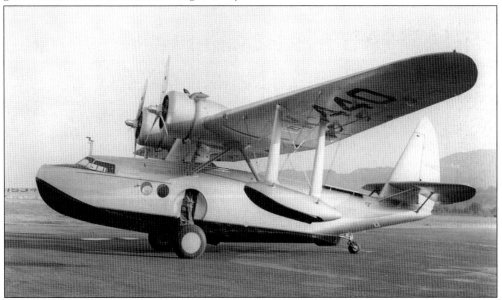

Hughes, a seaplane enthusiast, bought this Sikorsky S-43H for a projected record world flight that was abandoned. NX440 was rebuilt during World War II with greatly increased horsepower. An accident on Lake Mead during a high-speed water run killed two crewmen and seriously injured Hughes, exacerbating his reclusive nature. Rebuilt again, the S-43H remains airworthy as an aeronautical curiosity.

Howard Hughes boards his Boeing 307 Stratoliner for a practice flight. Deteriorating world politics rendered the high-flying airliner's usefulness moot. Its mission had been to establish a new around-the-world record. HRH's last prewar flight in the Boeing was on August 26, 1939. Less than a week later, Europe was engulfed in World War II. The Boeing remained in dead storage at GCAT for eight years.

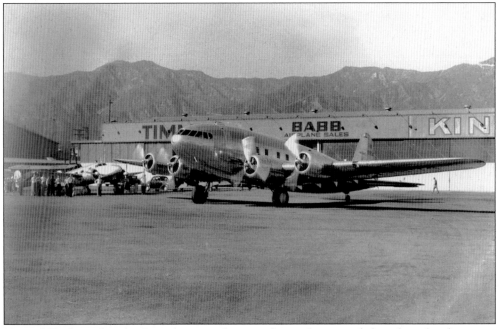

Howard Hughes takes the Stratoliner out for one of several two- and three-hour local practice flights. The Lockheed 12 parked to the left, on long-term loan from friend Joel Thorne, was a Hughes favorite for quick trips to Santa Barbara and Palm Springs.

Seven

WAR CLOUDS ON THE HORIZON

With Europe clearly headed for another war, the air corps, a long-neglected element of the U.S. Army, was woefully inadequate for any large-scale tasks, and a belated effort was being made to expand that service. The army and navy needed pilots, but the defense budget provided only a pittance to train them. Estimations were that three years were needed to bring the air arm up to strength with existing facilities. That was not good enough for Maj. Gen. Henry H. Arnold.

The newly appointed chief of the air corps, widely known as "Hap" Arnold, was studying a plan to contract with selected civilian schools to train cadet pilots—a revolutionary idea with no precedent since the days of the Wright brothers. Few insiders had much faith that Arnold could carry it off.

General Arnold and Major Moseley, having served together in the immediate postwar years, were the best of friends. Moseley had organized the aviation unit of the California National Guard in 1924. Prior to that, he had been in charge of training on General "Billy" Mitchell's staff. "Mose" understood the Army's way of doing things and he knew his way around Washington. His participation in the program was not only desired, it was expected. Arnold needed administrators he could trust for this grand experiment, which also expected participants to volunteer their equipment.

Moseley did not have a flying school at the time and could not be a contractor until he had one. The Curtiss-Wright Technical Institute was a school for technicians, mechanics, and engineers. It did not have a flight training program. Students desirous of learning to fly were sent across the field to Joe Plosser, whose Grand Central Flying School had exclusive rights to conduct flight training at GCAT. Moseley himself had set the terms, and the arrangement had worked well for all concerned. Now, however, he needed full control of a certified flying school, and he needed it quickly. The upshot of this was a joint venture with Plosser. The air corps contract was secured using Plosser's Grand Central Flying School as the base of operations.

The partnership never functioned as such, perhaps because the principals were accustomed to running their own shows. The school was to be staffed by air corps reservists, for one thing, and Plosser was unwilling to let his nonmilitary instructors go. They went their separate ways, and Moseley ended up with the GCFS. It was a takeover in name only. Plosser retained his

staff, facilities, and equipment and simply changed the name of the business to the Joe Plosser Air College.

"Hap" Arnold's "great experiment" was officially launched on July 1, 1939, when Class 40A, comprising 396 cadets, reported for primary training at nine civilian schools around the country. Those who finished the 12-week course would be sent to Texas for advanced training at Randolph and Kelly Fields. Washouts would be given second chances to qualify for flying as navigators and bombardiers. The program, designed to graduate 2,134 pilots by January 1, 1941, provided for new classes to be constituted at intervals of six weeks. It was understood that the contract program would last only as long as it took to bring the air corps up to strength. No one dreamt that it would not end until 193,444 pilots had been trained.

In the meantime, the Civil Aeronautics Administration (now the FAA) had implemented an experiment of its own in the interest of national defense, namely, the Civilian Pilot Training Program. The idea was to create a pool of college-trained pilots, male and female, which could be drawn upon in a national emergency. The air corps and the navy were to have first call on their services. Thirteen colleges and universities were recruited to participate in the training of some 300 handpicked students. This was carried out in the spring of 1939 with great success. The next step was to train 10,000 pilots with $4 million budgeted by the CAA. Glendale Junior College was among the schools picked to administer the CPT Program.

Glendale JC did not have an aeronautical department at the time, but a course in aircraft drafting was about to be offered. Someone was needed to teach the course, and it was assumed that whoever was hired would also teach CPT ground school, which involved only 10 students initially. GJC also needed a football coach, but the budget would not permit the hiring of more than one full-time instructor. Where would they find anyone who could teach football, engineering drawing, and aviation with the fall term fast approaching?

It was fortunate indeed for all concerned that Tom Ryan strolled into the office of Normal C. Hayhurst when he did. Hayhurst, as superintendent of Glendale Schools, did the hiring and firing. Ryan, then teaching aircraft drafting at a Burbank night school, had played football at USC. During the previous year, he had taught biology and coached a winning football team at Hoover High. Hayhurst, recalling the school's success, had spoken to Ryan about the vacancy at Glendale College. But the superintendent wanted to really know what Ryan knew about flying. "Oh," said Ryan, "quite a bit! I belong to the Lockheed Flying Club and they're teaching a bunch of us to fly. I'll soon have my license!" That was enough for Hayhurst. He had his one teacher in 10,000, and the CPT program got underway on schedule.

Joe Plosser contracted to give the primary flight training to Glendale's 10 CPT students. "They were all good boys!" Ryan recalled. All but one finished the course, and several went on to distinguish themselves in various branches of the military. In time, Ryan himself would don the gold wings of a naval aviator. By the end of the year, Plosser had 70 fledglings under his wing. Pasadena Junior College and Cal Tech had joined the CPT program and were sending their students to Plosser for flight training.

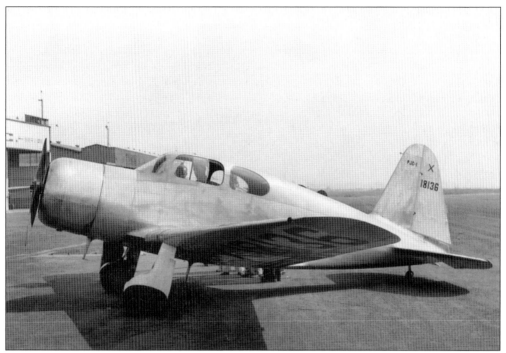

The prototype Harlow PJC-1, engineered and student-built at Pasadena Junior College, supervised by Max Harlow, became a commercial enterprise under former Howard Hughes aid J. B. Alexander, with Hughes's backing. The U.S. Department of Commerce ordered a batch of the production model PJC-2s for Civil Aeronautics Administration inspectors.

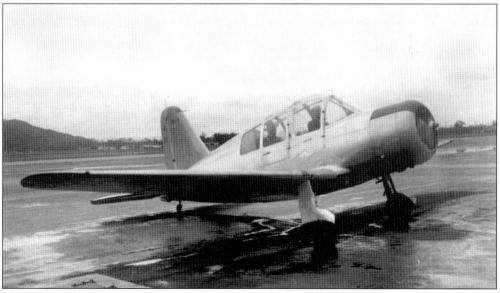

The Harlow PC5 military trainer, a spin-off of the PJC project, also utilized student engineers. Although the U.S. Army Air Corps rejected the design on the grounds that it was underpowered, it was picked up by the Indian government–owned Hindustan Aircraft, which had established a factory at Bangladore to manufacture trainers for the Royal Indian Air Force. The pilot is Harlow sales manager Jack Kelly, and the passenger has been identified as Howard Hughes.

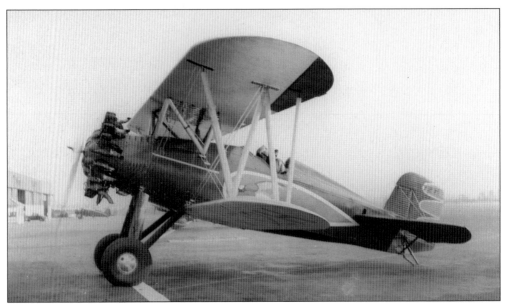

Playboy flier and Indy racer Joel Thorne, heir to the banking millions that built the Erie Canal and Pennsylvania Railroad, is pictured in his Boeing 100. Thorne and Howard Hughes were kindred spirits, sharing airplanes and girlfriends. Thorne's recklessness, including spectacular crashes and police confrontations, culminated when his Bonanza plunged into a North Hollywood apartment, killing the flier and several residents.

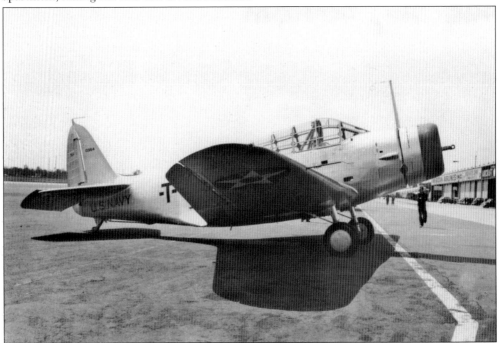

Major Moseley's military standing ensured regular visits by brass, often with the latest equipment, including this Douglas TBD Devastator torpedo bomber, minus its propeller after a landing mishap. The first carrier-based monoplane in U.S. Navy service, the TBM was judged useful against the Japanese early in 1942 but thereafter fared poorly.

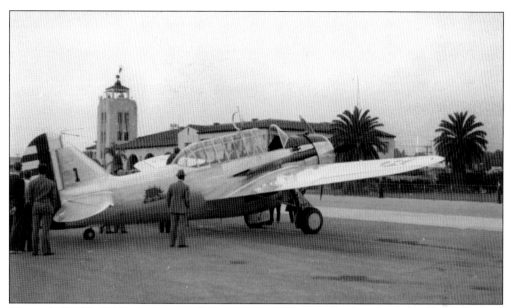

The potbellied 0-47, North American's first venture into the field of combat aircraft, was designed for photo reconnaissance. The O-47s were mostly posted to National Guard units, such as the 115th Observation Squadron based at Griffith Park, GCAT's precariously close next-door neighbor.

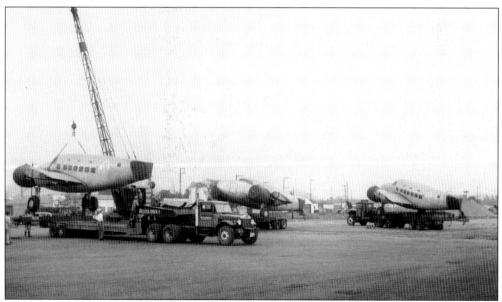

Japan Air Transport ordered 10 of these Lockheed Model 14WG3 Super Electras. The Babb company readied them for sea shipment. Tachikawa Aircraft, a leading Japanese manufacturer, subsequently produced 20 under license.

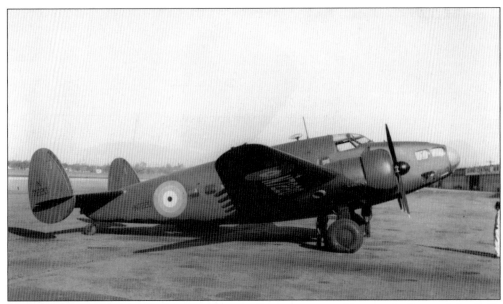

The 16th Hudson off the Burbank production line awaits sea shipment in front of the Babb hangar. The N7220 was converted to transport VIPs and may well have been utilized by Winston Churchill, an early flying enthusiast who enjoyed taking a turn at the controls as England's wartime prime minister. The Hudson program, which produced 2,941 aircraft, put Lockheed in the aviation big league.

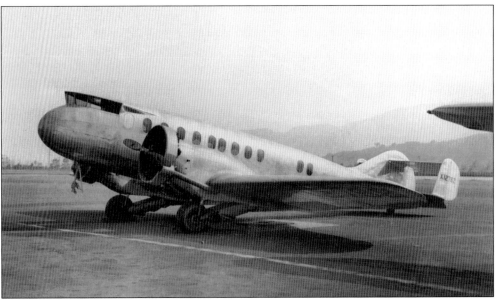

The grotesque Capelis C-12 was built by members of San Francisco's Greek colony from a design by Socrates Capelis. It languished largely unflown at Alameda until Jack Beilby ferried it to Glendale for broker Charlie Babb. A forced landing at Fresno, with the landing gear retracted, resulted in little damage. Beilby delivered the airplane to Babb and took a supervisory job under Major Moseley.

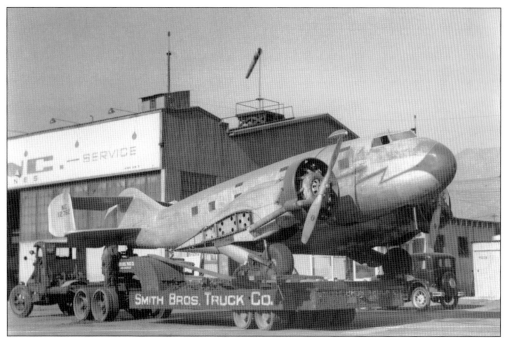

Among the C-12's shortcomings was the use of PK screws instead of rivets. The screws all worked loose from engine vibration. CWTI students attempted to remedy the problem by applying thousands of bits of scotch tape, and the Timms gave it a face-lift. Babb brokered the XC-12's sale to RKO as a nonflying studio prop. Smith Brothers moved it from location to location for such films as *Five Came Back*, *Flying Tigers*, and *Night Plane from Chungking*.

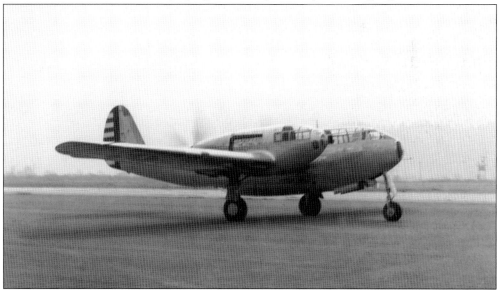

Looking a bit too futuristic to be practical, the Bell YFM-1A Airacuda was supposed to be top secret. Twin nacelles housed a 37-millimeter cannon forward and 1,050-horsepower Allisons aft. The trouble with that arrangement was that the crew was likely to become mincemeat if they tried to bail out. Multi-seat fighters had yet to be viable, and the AAC's 10 YFMs were given to schools as teaching aids.

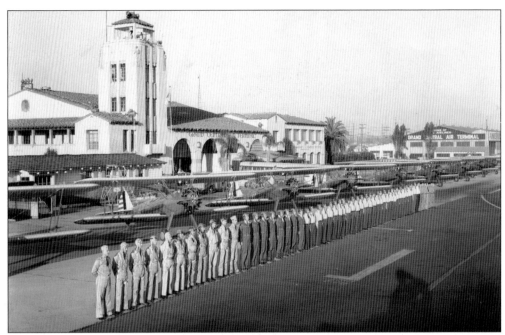

The first class of air corps cadets trained at Glendale with their Stearman PT-13s in July 1939. Escalating quotas forced the U.S. Army Air Corps to contract with civilian schools to train pilots and mechanics. Launched with misgivings, the program was a huge success. American Airlines was evicted toward the end of the year to provide hangar space for the air corps.

GCAT is viewed here from 10,000 feet. Visible in the lower right quarter is the California National Guard's 115th Observation Squadron at Griffith Park, with several planes on the concrete apron. The Flying Club of California, visible on the banks of the Los Angeles River, would soon become military quarters and classrooms. The proximity of two airports created the potential for disaster, so Griffith Park closed in 1941.

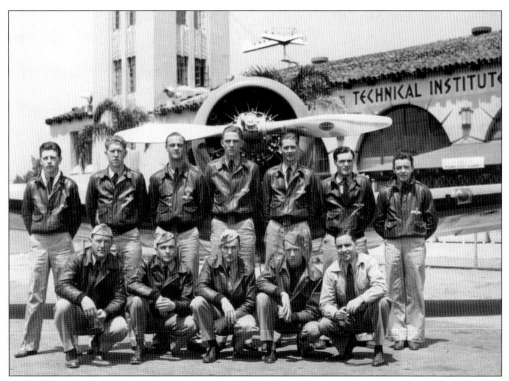

Early Polaris-trained American volunteers for the RAF pose with one of their Spartan 7W trainers. Pictured here, from left to right, are (first row) chief instructor Garland Lincoln; and instructors Bob Theobald, Hank Reynolds, Pete Callagy, and Frank Argall; (second row) Stephen H. Crowe, who flew Hurricanes, Spitfires, and survived into old age; Al Straul, believe killed in action; Howard Coffin, wounded in North Africa and author of *Malta Story*; Hugh Mc Call, killed in action, 1942; Pete Steele, killed in action, 1942; George R. Bruce, killed in a flying accident, 1941; and Eddie Streets, killed in a Malta air raid.

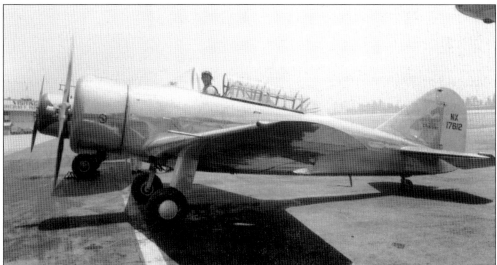

Garland Lincoln, chief instructor, is in the Spartan 8W, a one-only, tandem-seated, advanced trainer on loan to Major Moseley's Polaris Flight Academy for service testing.

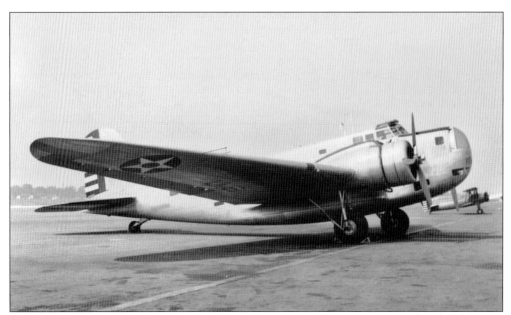

Another Douglas on the Glendale flight line was this bovine B-18 bomber, derived from the civilian DC series but with none of the appealing lines. Many B-18s stationed on Hawaii were destroyed on the ground during the Pearl Harbor attack. Most squadrons reequipped with B-17s, and the B-18s were largely relegated to antisubmarine patrols in the Caribbean.

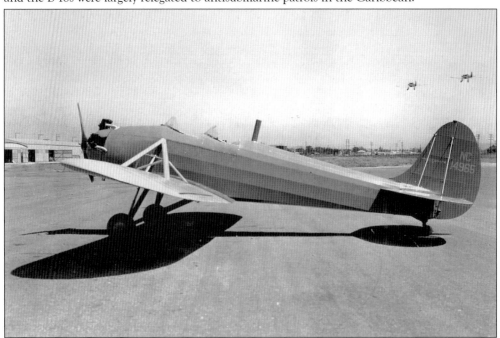

Wally Timm's enigmatic 2AS Aerocraft was a hasty conversion of the Kinner B2R Sportwing to meet an air corps requirement for for a primary trainer. It was rejected in favor of the Fairchild PT-19. Six units were delivered to Civilian Pilot Training Program operators before production was abandoned to concentrate resources on an entirely new molded-plywood trainer for the navy that enjoyed a measure of success as the N2T.

This is a Naval Aircraft Factory N3N-1 trainer from the U.S. Navy Reserve station in Long Beach. The navy continued to use N3Ns on wheels and floats until 1961, when the last ones were retired from the Annapolis Naval Academy midshipman program. They were the last biplanes in U.S. military service.

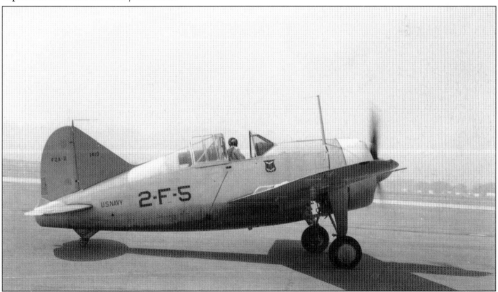

A rare visitor from the *Saratoga*, this Brewster F2A-2 Buffalo was piloted by a chief petty officer. Buffalos flown by navy and marine pilots fared poorly against Japanese Zeros in early battles over the Pacific and saw little if any combat thereafter.

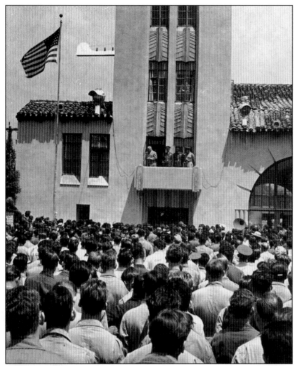

The presence of celebrities and VIPs got to be commonplace. Air marshal Billy Bishop, Canada's leading ace in World War II, was a frequent visitor. He is pictured here being introduced by Major Moseley.

VIPs attend the first Polaris graduation of Royal Air Force cadets in April 1941. Pictured, from left to right, are air marshal Guy Garrod, chief of RAF training; Maj. Gen. Barton K. Yount, commanding officer of the U.S. Army Air Corps West Coast Training Center; Major Moseley of the Polaris Flight Academy; Maj. Frank E. Benedict, commanding officer of Training Detachment, Glendale; and group captain Nigel Douglas-Hamilton.

Eight

THOSE AUDACIOUS YOUNG MEN IN THEIR P-38S

The attack by the Imperial Japanese Navy on Pearl Harbor on Sunday morning, December 7, 1941, turned Grand Central into an armed camp overnight. The whole area was cordoned off and secured by several hundred guardsmen. It was chaos on Monday morning. Civilians milled around waiting for passes to be issued so they could go to work or get to classes at CWTI. Tensions mounted as rumors flourished. It was expected that the Japanese might launch an air strike on the mainland at any moment. The public was in a state of shock and disbelief.

The 1st Pursuit Group, charged with the defense of Los Angeles, was dispatched from its home base at Selfridge Field, Michigan. It had been the first fighter outfit to equip with the new and largely untested Lockheed P-38 Lightning. The P-38, unquestionably the hottest and most heavily armed fighter in anyone's arsenal, was a big airplane. Its twin 1,200-horsepower turbocharged Allisons gave it a top speed of 400 miles per hour.

The P-38 needed plenty of runway, and the three squadrons were deployed at Glendale, Los Angeles Municipal, and Long Beach. Glendale's runway, being on the short side at 3,800 feet, was lengthened by closing off Sonora Avenue to traffic and paving a narrow strip to Western Avenue. That gave it an additional 1,200 feet of runway and saved a fair share of P-38s, with their smoking engines and sweating pilots, from finishing aborted takeoffs in the Los Angeles River.

Grand Central was camouflaged most effectively, and from the air it appeared to be a housing tract. The runway had been painted to blend in with its surroundings. From the ground, however, the P-38s were highly visible, so much so that watching them came to be a popular pastime. Whole families would park themselves on the Southern Pacific embankment. Often, on Sundays and holidays, they would bring picnic lunches and make a day of it.

It was always a thrill to see a dozen P-38s coming in from patrol. The fighters would come screaming in from Burbank in a 30-degree dive, zoom across the threshold, and climb away in a tight turn, which brought them around for landing. Pilots would sometimes try to outdo one another in coming in low and fast. The tighter the turn, the hotter the pilot. They didn't always get away with it. Ben Donahue watched in horror one day when a P-38 pulled too tight a turn, flicked into a spin, and augered into the railroad tracks.

Glendale became headquarters for the 318th Fighter Wing, responsible for the operational training of P-38 replacement crews. Newly commissioned 2nd lieutenants (and the occasional Royal Air Force FO), having taken 30 hours of transitional P-38 time at Muroc (today's Edwards Air Force Base), spent their final 30 days of training at one of the OT bases. There were four: Glendale, San Diego, Santa Ana, and Van Nuys. Mostly the instructors were combat veterans of the North African campaign. The program called for an additional 70 hours of flying. After that, the pilots were posted overseas.

Twelve OT squadrons were based at Glendale. Royal D. Frey spent his 30 days with the 372nd Fighter Squadron in July 1943. The pressure of the earlier training stages had relaxed considerably, and life in the OT units was a whole lot less formal than it had been at Williams Field. There was more leisure time. Frey and his classmates were usually free in the evening to partake of the Hollywood nightlife and other diversions. There was never any shortage of girls and P-38 pilots were always accorded special treatment. They were known as "Yippee pilots," a term derived from earlier models of the Lightning bearing the YP-38 designation. There was a measure of mystique that came with the airplane. For a time, "Yippee pilots" stood apart from ordinary mortals, who counted it a privilege to pick up their bar tabs.

July was hot in that long-ago summer of 1943, and the young lions often put in their hours aloft all but naked. They even left their leather helmets behind. No one gave a second thought to what a flash fire in the cockpit might do for one's tan. Most were 19 or 20 and supremely confident in their indestructibility. There were certain things one was supposed to be taught during OT, but 30 days was precious little time to learn all the ropes. Frey only "went to altitude" (22,000 feet) once at Glendale, and no one showed him how to put on an oxygen mask until he got to England.

There was very little night flying. Frey made but one nocturnal outing in a P-38 while at Glendale. Los Angeles, still half expecting a Japanese air strike, was in total blackout. Frey was alone when he suddenly found himself bathed in a dazzling blue glare, the target of half a dozen searchlight crews. It was impossible to see anything outside the cockpit. Frey ducked down to keep from being blinded and applied what little he knew about instrument flying to stay in the air.

P-38s represented 90 percent of the traffic at Glendale for much of the war. Occasionally, transients would become disoriented by the camouflage. Once a B-17 pilot actually let down on the taxiway in front of the P-38 revetments. To everyone's amazement, he got the big bomber stopped within the available 1,500 feet. Not everyone was so fortunate, and salvage crews regularly had to extricate planes that had overshot.

The P-38s' twin turbocharged Allisons tended to overheat on hot summer days, and the pilot who lingered with his ground check was likely to find his engines venting coolant. In their haste to get airborne before needles got into the red, things were sometimes forgotten . . . like propeller settings. The turbo regulators were inclined to cut in and out at inopportune times, which could be damaging, especially when running on low-grade fuel when 100-octane was in short supply. Detonation could wreck an engine before the pilot could take corrective action.

If one of the Allisons blew up or lost power on takeoff before the pilot had accelerated to 120 miles per hour (the safe single-engine flying speed), he was in serious trouble. The P-38 would swing toward the dead engine, and the rudder was not powerful enough to check it. Pilots got into the habit of skimming the rooftops along the river bank until the speed was well above 200 miles per hour. These protracted low-level departures were supposed to be for safety's sake, but they were also an excuse to give onlookers a thrill.

The rationale behind the training program reflected the exigencies of the war at that stage; namely, give the young hotshots some hours and get them overseas. Much of what they needed to know had to be learned the hard way. Frey and 19 of his classmates were posted to the 55th Fighter Squadron, 20th Fighter Group, soon to be an element of Jimmy Doolittle's 8th Air Force in England. Of those 20, nine lost their lives in action. Five others were shot down, four of which became POWs, including Frey himself. Four finished their tours more or less unscathed, and two were transferred for medical reasons like combat fatigue. Such was the attrition rate for fighter pilots at that stage of the war in Europe. Casualties were somewhat lighter in the Pacific.

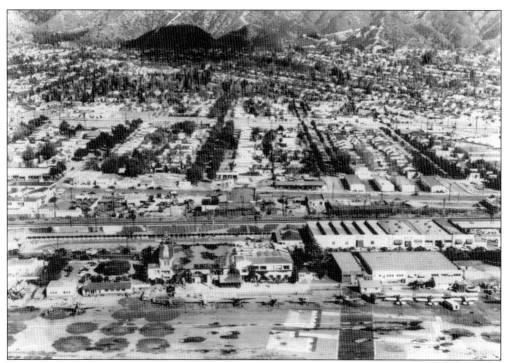

So effective was the camouflage that incoming pilots often had difficulty lining up with the runway, and a few missed it altogether.

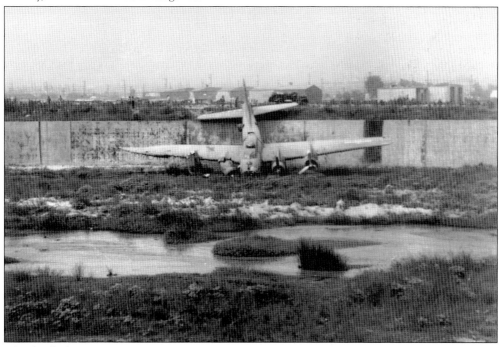

This badly bent Boeing B-17's pilot is thought to have mistaken the taxiway for the main runway. He overshot, ending up in the Los Angeles River. Lockheed was building B-17s under license in Burbank, several miles to the north.

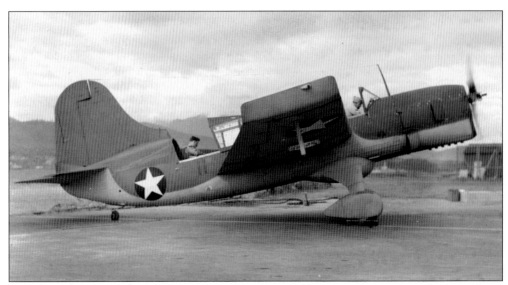

The underpowered and hard-to-fly Curtiss SO3C Seagull was grounded by the U.S. Navy after a poor showing in the Pacific. More than 100 were detailed to Glendale for use as radio-controlled target drones. Naval aviators were barred from flying the SO3C, so L. E. (Al) Phelan had to do all the ferrying himself. Navy gunners blasted them into extinction for practice.

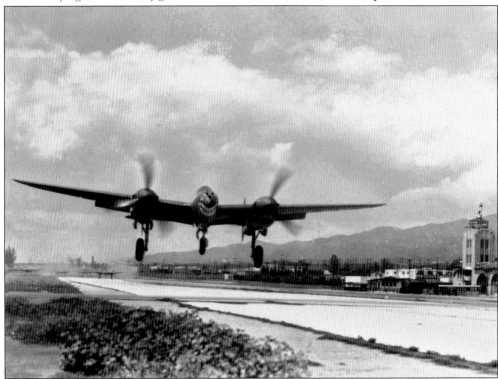

The first Lockheed P-38s, charged with the defense of Los Angeles, arrived in February 1942. The distinctive wail of Allison V12s, thrilling to younger ears and the bane of older ones, was a comfort to all when a Japanese invasion seemed imminent. The shark mouth, inspired by General Chennault's Flying Tigers in China, was nonstandard.

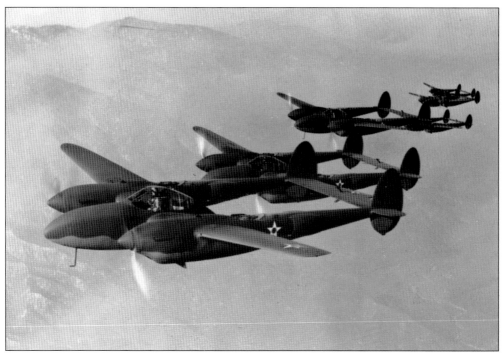

On dawn patrol in 1942, trainee pilots on the duty roster would peer out the barracks windows at first light. If they could see Mount Verdugo, the mission was on. If not, they would get another half hour of shut-eye. The usual itinerary was a sweep to Catalina and back, and this patrol comprised six unarmed P-38Ds.

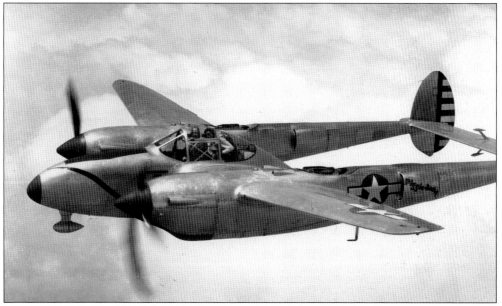

A frequent visitor to Glendale and other P-38 operational training bases was Jimmy Mattern in his famous *Piggy-Back*, an improvised two-seater P-38F. Mattern helped keep training accidents to a minimum by giving familiarization hops. Similarly modified P-38s were later issued to training units.

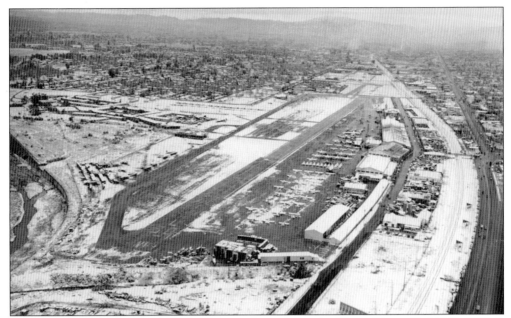

Grand Central experiences a liberal covering of snow, after the "Great Blizzard" of 1948–1949. It was the first time in living memory that skiers awakened to find enough snow for cross-country skiing on the city's streets. Visible in the upper left are the barracks and classrooms for wartime training. The relatively unoccupied triangle adjacent to the Los Angles River became the heliport and is today occupied by Dreamworks SKG.

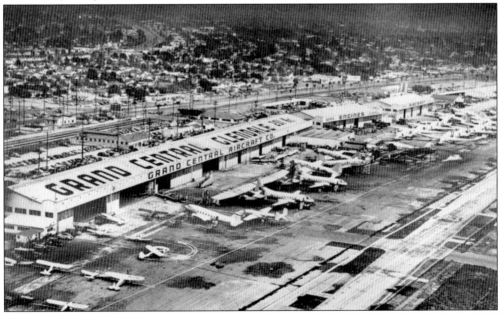

The busy GCA flight line is seen here in the spring of 1949, including part of the first batch of 100 Curtiss-Wright C-46 commandos for the U.S. Air Force, a pair of Catalinas for Brazil, a pair of Convair 240s belonging to the Republic of China Central Air Transport Corporation, and a B-25 for the Chinese Nationalist Air Force. Several C-47s are being converted for civil airlines as DC-3s. Camouflage still creates a confusing illusion on the runway and apron.

Nine

NOBODY KNEW THE BUSINESS LIKE BABB AND "MOSE"

The Grand Central Aircraft Company, founded in 1950, had its true beginning 16 years earlier when Major Moseley leased the airport from Curtiss-Wright. "Mose" and his associates formed Aircraft Industries, Inc., to provide the services expected of the West's busiest airport. The first of these was an engine repair shop that began operations early in 1934 with two master mechanics. The shop was supervised by one Charles "Chief" Kidder, a leathery old salt weathered by 18 years of naval aviation. Kidder was extraordinarily talented and marvelously profane.

The shop's first overhaul job was on the 125-horsepower Kinner in Joe Plosser's Travelair 16K instrument trainer, followed by a 400-horsepower Pratt and Whitney Wasp for Wrigley's Catalina Airlines. Both outfits became regular customers. From the outset, Aircraft Industries, Inc., was the authorized sales and service agency for Wright engines. In the latter part of 1934, the company assumed the distributorship for Stinson aircraft and Lycoming engines for Southern California. By the end of the year, the company had a payroll of eight.

A second development, equally significant, was the opening of the Charles H. Babb Company in an adjoining hangar. Babb, an eminently successful airplane broker, had clients worldwide. No one could top him for bringing buyers and sellers together. Babb officiated over the change of ownership of all sorts of aircraft, but the workhorses of the air were his main stock-in-trade. The secret of Charlie's success was in knowing who needed what—be it a Granville Brothers Gee Bee Special or a Ford trimotor—and where the desired article could be found.

Babb was said to have sold more Lockheeds than the company had built. It was probably true. The Babb Company sold and resold scores of Vegas and Orions, some of them several times in the course of the decade. He also sold engines and spare parts. The Babb warehouses were crammed with bits and pieces from thousands of planes. Charlie would stroll into the big hangar, pluck a stray washer from the floor, and deposit it in the right container among thousands on the shelves. He knew exactly where everything belonged. Babb also knew that there was a buyer for everything, and he made that knowledge pay. Customers might grumble at his prices, but no one doubted for a moment that the merchandise was anything less than advertised.

The Aircraft Industries engine department expanded steadily and moved into the hangar vacated by Vultee late in 1935. By the summer of 1939, with Moseley's air corps contract school in operation, it was necessary to open an airplane repair department to maintain a fleet of Stearman PT-13 trainers. Accidents were daily occurrences, most of them fairly minor ground loops. Within the year, the original fleet of 20 PT-13s had grown to 60 and Glendale had become headquarters for Moseley's satellite schools at Ontario, Lancaster, and Oxnard.

Not long after Pearl Harbor, the engine department received 40 Wright R2600 engines. They were brand new and had been handpicked by the air corps for a requirement that was top secret. The engines had only about five hours of run-in time, but were torn down to the irreducible minimum and carefully inspected. Any part showing the slightest imperfection was replaced. Afterwards they were hustled back to the North American plant at Inglewood. It was not until the end of April 1942, after Doolittle's raiders had given the Japanese capital its first drubbing, that the mission for which the R2600s had been groomed was made known. The Doolittle Raid remains an enduring milestone in U.S. military history.

Grand Central Air Terminal, which had been leased from Curtiss-Wright since 1934, was purchased outright by interests headed by Major Moseley in June 1944. At this juncture, the "Air Terminal" was dropped in favor of "Airport." It had, in fact, ceased to be a terminal when Mexicana moved out some months earlier. Aircraft Industries, Inc., became the Grand Central Airport Company. Its two divisions continued to be airplane repair and engine overhaul, largely for the airlines in the immediate postwar era, all of which was overseen by the ubiquitous and indefatigable "Chief" Kidder.

The Curtiss-Wright Technical Institute, having completed the training of the last class of air corps mechanics, became Cal-Aero Technical Institute. The name change did not involve the contract flying schools, which had closed down. Pilot training had been curtailed by late 1944, and the contract schools had been phased out altogether by the war's end.

With its 5,000-foot runway, GCA was a Class IV airport, with no limits as to the size of the aircraft permitted to use the runway. The unrestricted use became an issue, which elicited support for elements hostile to the airport, and the Class IV status was short-lived. Pressure was brought to bear, and the runway extension to Western Avenue, built in 1942, was closed by municipal decree in 1947. The loss of 1,200 feet of runway made it a Class II facility, sufficient for the DC-4s (C-54s) then coming in for overhaul and the occasional Lockheed Constellation. The "Connies" needed every inch of runway, and hard braking sometimes caused one or more tires to blow.

The Airplane Repair Division was soon doing a thriving business in production-line reconditioning of military aircraft, mainly for Third World nations, a large part of it generated by Charlie Babb. One of the first big contracts since the war was for 200 North American AT6 Harvards that Babb had acquired from Canada and sold to Nationalist China. The AT6s were followed by 100 Curtiss-Wright C-46 Commandos, also for China, and a further 50 were reconditioned for the Air National Guard.

The Korean War brought a surge of new air force work, necessitating an expansion of both departments. Moseley reorganized as Grand Central Aircraft and named his son-in-law, Robert O. Denny, a former fighter pilot, as president. GCA had contracted to refurbish 200 B-29 Superfortresses stored at Davis-Monthan Air Force Base, and the Tucson Division was formed for that purpose. A 10-year lease was taken on facilities at the municipal airport adjoining Davis-Monthan. Meanwhile, in Glendale, Douglas C-47s and North American P-51 Mustangs were being reconditioned and updated for Korean service. Never before had the hangars been so busy.

Cal-Aero Technical Institute, having resumed the training of Air Force mechanics in October 1950, received additional contracts that extended the program nearly two years. Altogether, 1,200 air force men were trained at Glendale, the last of which were graduated in August 1952. By that time, the air force training establishment could handle the quotas without civilian help. Thereafter, Cal-Aero's fortunes declined steadily. The student body fell from a high of 1,500 to a low of less than 200. The school lost money for three years running and closed its doors at the end of the 1954 term.

Perceived as an airplane millions of Americans could afford, including returning veterans, the Ercoupe 415C featured simplified controls that eliminated the rudder pedals. Theoretically, it could be flown equally well by pilots with legs or without. GCA's Ercoupe Division sales manager, Dana Boller, is pictured with members of the first flying club created for handicapped veterans.

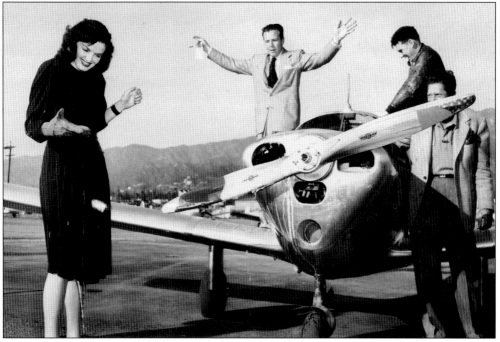

Hollywood stars Jane Russell and Dick Powell, himself an Ercoupe owner, are at the christening of one of the planes donated to a club for air-minded paraplegic veterans in November 1946. A thousand or more Ercoupes were assembled by Grand Central Aircraft for distribution throughout the West.

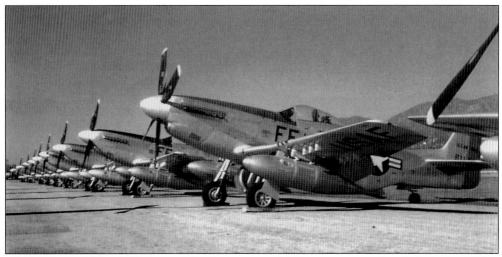

Pictured are a couple of squadrons of North American P-51D Mustangs, newly refurbished as F-51Ds for service in the KCOMZ, mostly serving as ground support. The auxiliary tank attachments later accommodated napalm and bombs in an effort to stop the red tide from swarming in from China. Mustang units in Korea suffered heavy losses performing a role for which they were never intended.

Art Woodley, right, a longtime customer of the Babb Company, collects his first Douglas DC-4 and a Lockheed 12 for his newly formed Pacific Northern Airlines. Woodley, a 1929 Kelly Field graduate, went to Alaska to seek his fortune in 1932. Beginning with a single Travelair 6B, he built Woodley Airways into a going concern that became PNA after World War II. Western Airlines later bought PNA and made Woodley a vice president in charge of Alaskan operations.

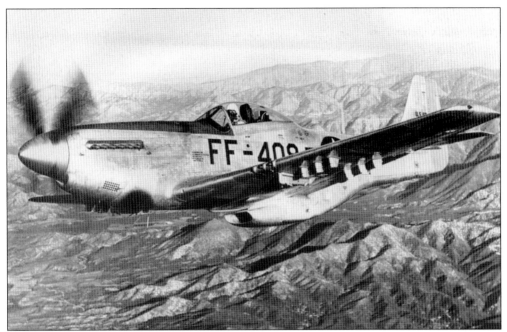

Grand Central Aircraft's chief test pilot, Bill Grago, forms up for a photograph in FF-409, a North American P-51D Mustang just out of the paint shop, almost certainly detailed for combat in Korea. Nearly 500 P-51s were sent to Glendale for overhaul and modification, most of them for service in Korea with U.S. and Canadian forces.

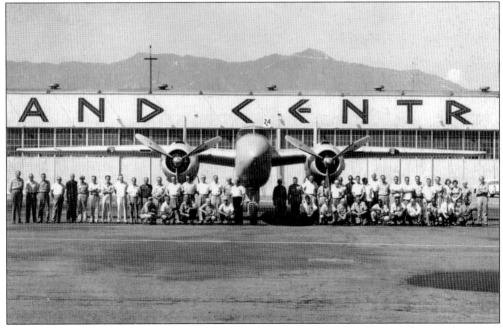

The first North American B-25 Mitchell converted for civilian use in the Grand Central Aircraft shops appeared as pictured with the department staff, including maintenance manager "Smiling Jack" Bielby, 11th from right, and the ladies of the clerical department. General Doolittle used B-25s in the famous first raid on Japan.

Fred Thaheld, designer of a 90-horsepower diesel engine for light planes, arrives in his Stinson to put on a demonstration. With aviation fuel plentiful at 20¢ a gallon, there was little incentive to follow Germany's lead in utilizing the heavy oil principal. In light of recent oil prices, aircraft builders are again thinking diesel.

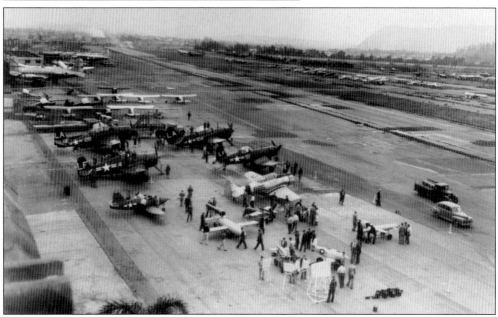

The U.S. Navy puts on a show to recruit, c. 1949, possibly for the first time since the war. Clockwise from a gaggle of missiles, including a copy of Hitler's V2 rocket bomb, is the navy's smallest man-carrier, a Culver PQ-14, mostly used as a radio-controlled drone; a pair of Grummans—a Hellcat fighter and an Avenger torpedo plane; Curtiss Helldiver dive bomber; Vought F4U Corsair; and a North American SNJ Texan trainer.

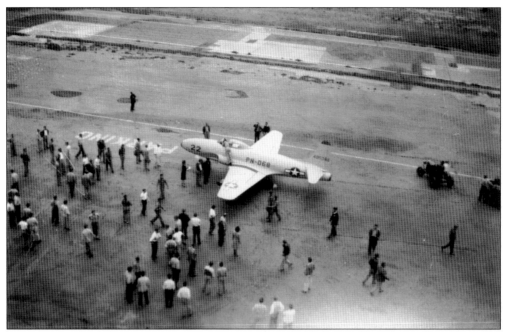

Grand Central's first jet-powered visitor was this Lockheed P-80 in 1946, built a couple of miles away. The air force used it before the end of World War II, but it saw no combat until the Korean War. PN-068 was among the first 200 P-80s built and quickly drew a crowd of Cal-Aero students eager to inspect leading-edge technology.

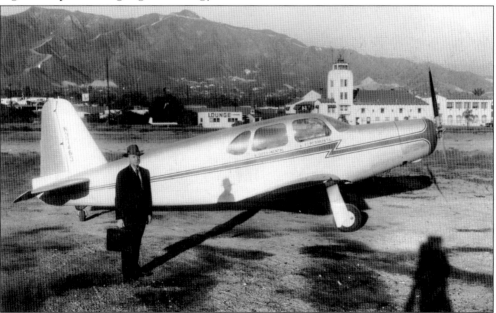

The Atlas H-10, a classroom project at Pasadena City College, became A. J. Alexander's obsession for three decades. He envisioned the production article with a pair of coupled 175-horsepower Franklins driving contra-rotating propellers to obtain twin-engine safety for the single-engine pilot. Major Moseley's interest explains the H-10's presence at Glendale into the 1950s. The enterprise evolved as the Mono-Twin in the 1970s, but mass production never became a reality.

Doug Anderson, down from Canada to add hours toward an Air Transport Rating, refuels the Glendale School of Aeronatics Piper PA-16 Clipper demonstrator. After a stint as a bush pilot, Anderson became a copilot with Air Canada, finishing his career as a senior captain with 30,000-plus hours several decades later.

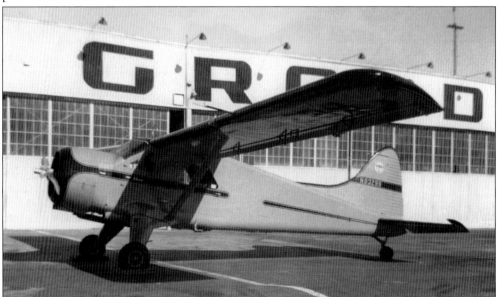

Charlie Babb's DHC-2 Beaver demonstrator is depicted in 1950. Babb became the U.S. agent for deHavilland of Canada through having supplied the manufacturer with large quantities of surplus 450-horsepower Pratt and Whitney engines. Babb persevered against a reluctance to buy imported aircraft within agencies of the federal government, sending his demonstrator to Alaska to show the army what it could do. Nearly 1,000 were sold to both the army and air force under the L-20/U-6 designations.

Ten

AIRPORT IN DECLINE

Grand Central Aircraft settled into the doldrums after the Korean War. The Tucson Division, which had not panned out as expected, soon closed. Major Moseley was being pressured to close Grand Central Airport itself, and plans were already afoot to convert the property into a large industrial complex, with or without a runway. Bob Denny, seeing the writing on the wall, formed On Mark Engineering at Van Nuys Airport to customize Douglas A-26 Invaders and other war surplus aircraft for corporate use.

Major Moseley was looking well into the future when, in 1955, he formed the Grand Central Rocket Company. This was primarily an R&D venture, and it had a tie-in with Project Vanguard, the Earth-satellite launching program. The company engaged in developing solid rocket propellants at its plant in Mentone, near Redlands. Some testing of rocket fuels was carried out at Glendale in one of the old P-38 revetments.

Grand Central Rocket was associated for a time with Ford's Autonutronic Systems, Inc., in Glendale, which was seeking to put a heavily instrumented, one-ton projectile several thousand miles into space. The project was called "Operation Far Side." It was the summer of 1957, and *Sputnik I* had yet to go into orbit. Outer space had been penetrated only about 600 miles.

By 1958, Grand Central Rocket was a major producer of rocket fuel for missiles and research. Early in the year, it was traded to Tennessee Gas and Transmission. Petro-Tex Chemical took a controlling interest a few months later. Within two years, it was wholly owned by Lockheed, which changed the name to Lockheed Propulsion Company.

Major Moseley's retirement from the rocket business coincided more or less with the creation of Grand Central Aircraft's Fresno Division, which occupied the old North American facility at Chandler Field. The division was engaged exclusively in overhauling Lockheed T-33 jet trainers for the air force. The contracts petered out within two years, however, and the facility closed down.

Grand Central Airport was now in the twilight of its life. Taxes were escalating, and income from supporting industry and services was in a corresponding decline. Major Moseley's managers were chafing to get on with the industrial development. The runway had not been maintained. The unpaved parallel strip, which was mainly used for training by the Glendale School of Aeronautics, was riddled with ground squirrel burrows. The tower, too, had been abandoned, and the airport was operating as an uncontrolled facility. The only element still being developed was the Grand Central Heliport in the southwest corner, adjacent to the L.A. River, which had a secure future for decades to come.

The sod runway was in a sorry state of disrepair when the author, ignorant of its condition, landed amid the tumbleweeds. The aircraft was still rolling when the ground gave way under

one wheel, and it pirouetted to a standstill. No amount of throttle jockeying could free the wheel, and the plane's entrapment by the ground squirrel colony was logged in as a victory for the varmint kingdom.

The only encouraging development involving GCA's future was an effort by Jack Frye to establish a manufacturing enterprise in the West, which included the Helio Aircraft Corporation, builders of the Courier STOL (slow takeoff and landing) airplane. Frye had plans for a four-engine freighter, too, and there were rumors that a civilian version of the trimotored Northrop C-125 Forwarder might be manufactured under the aegis of a consortium headed by Frye. The dynamic former head of TWA had the resources to make it happen, but his death in a Tucson traffic accident created a void that no one else could fill.

There was a movement to save part of the airport, spearheaded by Los Angeles television anchor Clete Roberts, a lifelong flying enthusiast, with considerable support from other interested parties. Glendale City Council was petitioned to make it a municipal airport. But once again, as in the 1920s, the petitioners were to be disappointed. Their last hope was the County of Los Angeles. The board of supervisors deigned to hear the citizens committee appeal but failed to raise a plurality. It was thumbs-down for Grand Central Airport.

There were several postponements of the closure but no reprieve. Tom Ryan had moved the Glendale School of Aeronautics to San Fernando Airport, which was close enough to accommodate the Glendale College flight training program, ongoing since World War II. Nearly all of the smaller hangars were being dismantled for reerection at the newly created Aqua Dulce Airport, located midway between Los Angeles and Palmdale.

Time ran out on July 15, 1959. One by one, the handful of remaining aircraft took their leave. A man with a jacked-up Stinson rushed frantically about, searching for a set of tires. The deadline for departure was sundown. After that, the runway was officially closed. Inoperative aircraft were to be dismantled and hauled away. Tom Ryan, climbing into a twin-engine Piper Apache belonging to the Glendale School of Aeronautics, was one of the last to leave. "It's the same old story," said Ryan. "Taxes go up and the airports go under!" It was well past sundown when Dave Thompson's Taylorcraft cleared the runway, completing the exodus.

Boeing YL-15, built for the army in 1947–1948, was designed to be folded up and transported by air or surface means. A dozen were service-tested in Alaska and elsewhere, but cutbacks precluded further deliveries. The YL-15s were eventually handed over to the U.S. Forestry and Fish and Wildlife Services. "El Burro" ended up at GCA with Pacific Automation performing survey work and research and development in connection with "earth current" (ULF) for the U.S. Navy (JWU).

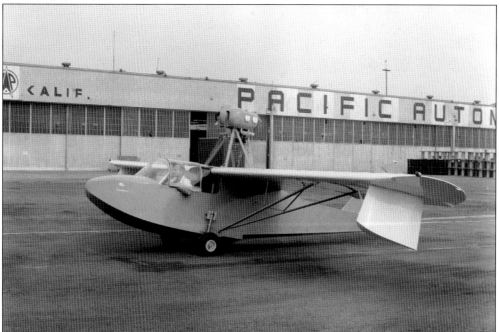

Glendale inventor and scuba enthusiast Volmer Jensen, a disciple of Jacques Costeau, designed his own underwater camera and a two-place amphibian to more easily access remote diving sites in Baja California. Jensen built the VJ-22 "Chubasco" at home and flew it from GCA in 1958–1959. Hundreds more were homebuilt by do-it-yourselfers from blueprints and kits marketed worldwide.

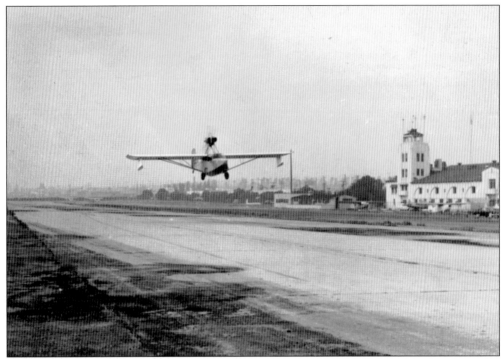

The VJ-22 had the GCA runway all to itself. Traffic had dwindled to the point that there was no need for anyone in the control tower.

Jack Frye, who brought TWA to GCAT in 1930, returned with the Helio H-391B Courier in the late 1950s in the hope of establishing a new home for the company. A Grand Central factory in Tucson, Arizona, had been selected to produce both the Courier and a trimotored Northrop freighter when Frye lost his life in an automobile accident.

The far-flying Max Conrad, with a local traveling companion, inspects Major Moseley's DC-3 *Full House* in 1951. When Conrad closed his logbook forever in 1979, he had 52,929 certified hours, equal to more than six years in the air. Not until the 21st century could anyone top that.

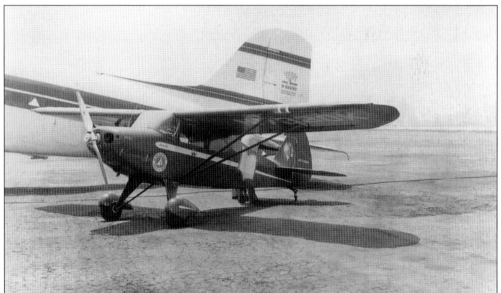

Conrad's Piper PA-20 Pacer was famous for having spanned the Atlantic twice in September 1950, making a vacation round-trip to Switzerland. NC7330K, pictured sharing parking space with Major Moseley's DC-3, had just set a coast-to-coast nonstop record for light planes of 23 hours and four minutes. In 1953, Conrad visited 48 state capitols, celebrating the 50th year of powered flight.

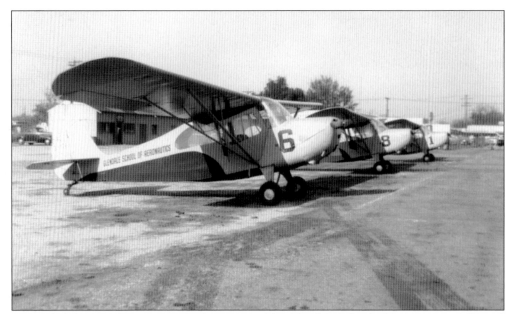

Pictured is a lineup of Aeronca 7AC Champions of the Glendale School of Aeronautics. Affiliated with Glendale College's aviation department, GSA trained hundreds of returning veterans under the GI Bill and hundreds more seeking air force and naval aviation cadet appointments.

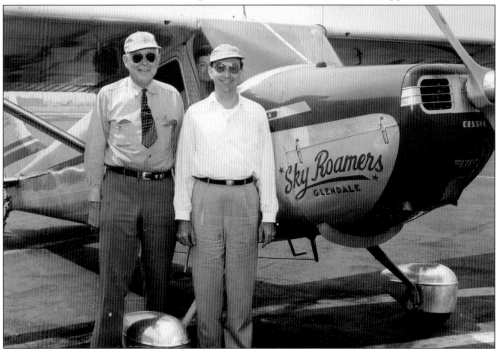

The Sky Roamers flying club was formed with 10 members around a single Aeronca Champion in 1946 and remained GCA-based for 10 years. Its expanding ranks necessitated a move to larger quarters in Burbank, where it became the largest flying club in the United States, with well over 300 members and 30 planes. "Smiling Jack" Beilby, left, a GCA icon, and Joe Ware are pictured with the club's first Cessna 170.

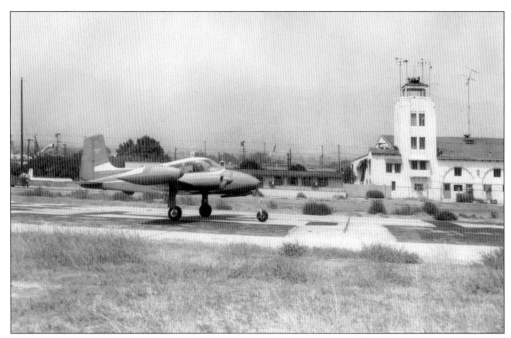

July 15, 1959: This Cessna 310, NC1310H, was officially the last plane to depart Grand Central Airport within the prescribed daylight time limit. Others exited on the q.t. under cover of darkness before bulldozers demolished the runway the next morning. The overgrown turf portion had long since been abandoned to the varmint kingdom.

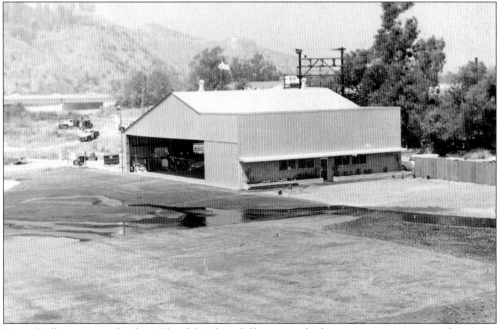

Dana Boller was involved in Glendale's last dalliance with the air transportation industry, an attempt to keep part of the airport property for flying operations. The result was the Grand Central Heliport, built in 1958 by the National Helicopter Corporation. When the NHC moved to Van Nuys, the facility became a police heliport. It is now the site of Dreamworks SKG.

Boller, pictured here demonstrating the new Brantley B-2 to World War II Marine fighter ace Gregory "Pappy" Boyington, became sales manager of Brantley-Pacific on July 31, 1962. He was killed two days later while ferrying a new Brantley from the factory.

The Brantley B-2 was the smallest and by far least expensive helicopter on the market when it made its Western debut at Glendale in 1960. Howard Hughes was quick to take up the challenge of producing a competitive model.

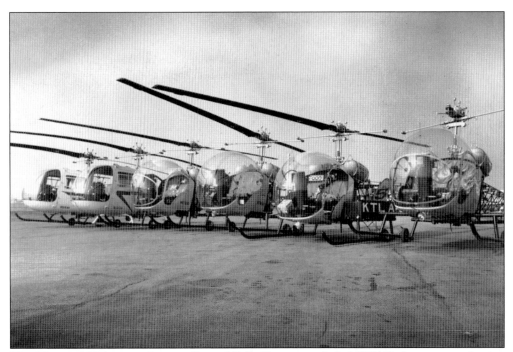

The National Helicopter Service fleet of Bell 47 series included KTLA's first news-gathering helicopter. The company became instrumental in planning and establishing many heliports throughout Los Angeles County, establishing its own headquarters at Van Nuys Airport.

The visionary L. C. Brand could not have imagined in his wildest dreams that the County of Los Angeles would launch, almost from his very doorstep, a type of aircraft yet to be conceived in practical form. Helicopters did not exist in Brand's day. Long after the Grand Central Heliport had ceased to function, the grounds of Brand's estate once again offer respite to airmen. Brand Park remains an emergency refueling and retardant pickup spot for firefighting helicopters.

ACROSS AMERICA, PEOPLE ARE DISCOVERING SOMETHING WONDERFUL. *THEIR HERITAGE.*

Arcadia Publishing is the leading local history publisher in the United States. With more than 3,000 titles in print and hundreds of new titles released every year, Arcadia has extensive specialized experience chronicling the history of communities and celebrating America's hidden stories, bringing to life the people, places, and events from the past. To discover the history of other communities across the nation, please visit:

www.arcadiapublishing.com

Customized search tools allow you to find regional history books about the town where you grew up, the cities where your friends and family live, the town where your parents met, or even that retirement spot you've been dreaming about.